ANZA-BORREGO

A PHOTOGRAPHIC JOURNEY

ANZA-BORREGO

A PHOTOGRAPHIC JOURNEY

Ernie Cowan

ANZA-BORREGO
FOUNDATION AND INSTITUTE

CALIFORNIA STATE PARKS
COLORADO DESERT DISTRICT
ANZA-BORREGO DESERT STATE PARK®

SUNBELT PUBLICATIONS
San Diego, California

ANZA-BORREGO: A PHOTOGRAPHIC JOURNEY
Sunbelt Publications, Inc
Copyright © 2008 by Ernie Cowan
All rights reserved. First edition 2008

Edited by Jennifer Redmond
Cover and book design by Kathleen Wise
Project management by Jennifer Redmond
Printed in the United States by Taylor Specialty Books, on 10% post-consumer recycled paper.

Anza-Borrego Desert State Park® and park logos are registered trademarks of California State Parks.

No part of this book may be reproduced in any form without permission from the publisher.
Please direct comments and inquiries to:

Sunbelt Publications, Inc.
P.O. Box 191126
San Diego, CA 92159-1126
(619) 258-4911, fax: (619) 258-4916
www.sunbeltbooks.com

12 11 10 09 08 5 4 3 2 1

"Adventures in the Natural History and Cultural Heritage of the Californias"
A series edited by Lowell Lindsay

Library of Congress Cataloging-in-Publication Data

Cowan, Ernie.
 Anza-Borrego : a photographic journey / Ernie Cowan. — 1st ed.
 p. cm. — (Adventures in the natural history and cultural heritage of the Californias)
 ISBN 978-0-932653-88-8
 1. Natural history—California—Anza-Borrego Desert State Park. 2. Natural history—California—Anza-Borrego Desert State Park—Pictorial works. 3. Anza-Borrego Desert State Park (Calif.)—Pictorial works. I. Title.

QH105.C2C665 2008
508.794022'2—dc22
 2007046322

All photographs by Ernie Cowan; author photos: Katalin Cowan

SPONSORS

Publication of this book made possible through the generous support
of the following organizations, businesses, and individuals:

BARONA BAND OF MISSION INDIANS

ROBERT BEGOLE

CALIFORNIA STATE PARKS FOUNDATION

TIM AND CLAUDIA COSTANZO

IN MEMORY OF JOHN R. FLEMING AND GUY L. FLEMING
MARY BETH FLEMING WRIGHT

RICK, TORY AND LUKE GULLEY

PROTECT OUR COMMUNITIES FUND

ROMA PHILBROOK RENTZ

GEORGE SARDINA, MD

TWENTY-NINE PALMS BAND OF MISSION INDIANS

DAVID H. VAN CLEVE

WELLS FARGO

MRS. FRANK WHEAT

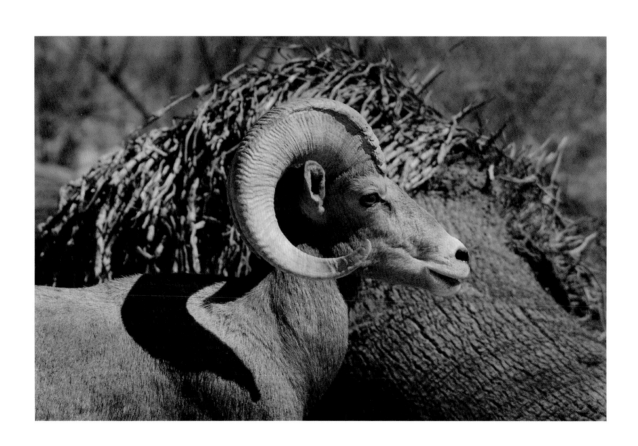

FOREWORD

Anza-Borrego Desert is the giant of California State Parks. In natural and cultural resources, ecological diversity, pristine vistas, majestic silence, and sheer size, it rivals many of our national parks and monuments. Because of a quirk of timing at the beginning of the Great Depression, Anza-Borrego Desert State Park missed being given national park status but became the foundation for the newly formed California State Park System—the first in the nation. It is nearly half of the state park system in size. At almost 650,000 acres—nearly the size of the state of Rhode Island, it is the largest contiguous state park in the continental United States. Much of it remains untouched and untrammeled true wilderness. Almost 90 per cent of the California state wilderness system is within the boundaries of Anza-Borrego Desert State Park, and much of the land surrounding the Park is either part of the federal wilderness system or has similar federal protection.

The unusual name of the Park captures both its cultural connection to the past and its mission to protect the natural resources within its boundaries. Juan Bautista de Anza was the Spaniard who, while crossing the heart of the Park, found the first land route to California. *Borrego* is Spanish for a yearling lamb, representing the endangered Peninsula bighorn sheep.

Anza-Borrego Desert State Park exists today, over 75 years later, because of the vision, action, and guardianship of individuals and organizations that recognized its unique value and wanted to preserve it for future generations to enjoy. The Anza-Borrego story is a tale of visionaries confronting challenges, of conservationists prevailing in the face of development, and of the ongoing vigilance needed to protect one of the nation's finest and largest desert parks against the threat of indiscriminate use, transmission lines, or roads through sensitive habitats. It was so in the beginning, and it remains so to this day.

Parks today need partners in the constant struggle to protect the "forever" element in their slogan "Parks are Forever." For this park, that partner is the Anza-Borrego Foundation and Institute. For 40 years the Foundation, a non-profit 501(c) (3) charitable trust, has played a key role in land acquisition of private inholdings within the boundaries of the Park. In 2003 the relationship took on a new dimension with the formation of the Anza-Borrego Institute, broadening the Foundation's mission beyond acquisitions to include education, interpretation, and scientific study of the Park and the surrounding ecological region. Now known as the Anza-Borrego Foundation and Institute, the organization sponsors a 5th grade environmental education camp, an online distance learning program for students throughout southern California, year-round adult education classes, and adult volunteer programs. The Institute hosts scientific symposiums, awards scholarships for scientific research, and actively supports the district paleontological and archaeological societies. For further information visit the website: www.theabf.org.

As southern California continues to grow, undisturbed open spaces like Anza-Borrego Desert State Park will become a rare commodity. "Parks are Forever" takes on a new significance in areas that are so sensitive to man's intrusion that landscapes may become irreparable in one's lifetime if left unprotected. Complete commitment to conservation is critical if we are to maintain the pristine quality of the landscape for the next generation. This can only happen if we pass along an appreciation for these land values, and this comes through education. A visual presentation is one of the best ways to appreciate this Park, and this book is such a presentation—a journey through the Park and surrounding region which highlights many of the intrinsic values that originally called for its preservation. We protect what we love and what gives meaning to us.

Photographer and journalist Ernie Cowan brings together stunning images that capture the spirit of the land and heartfelt words that express why this land touches so many people in a special way. He captures the essence of the desert, helping us to understand why it calls and holds one as no other landscape can. Let the journey begin!

Diana Lindsay
Vice-President Environmental Affairs
Anza-Borrego Foundation and Institute

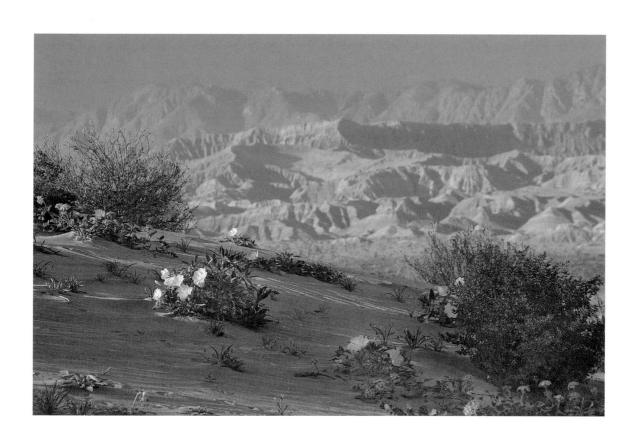

PREFACE

Have you wandered in the wilderness, the sagebrush desolation,

The bunch-grass levels where the cattle graze?

Have you whistled bits of rag-time at the end of all creation,

And learned the desert's little ways?

ROBERT SERVICE FROM "CALL OF THE WILD"

THERE IS A LONELY PLACE I know where you can spend days and not see another soul. The quiet lets you hear little things like a bird's wing beats, along with many of Nature's other wonders, which can be both silent and delicate.

Such a treasure of natural wonder and beauty may sound like a far away place, but it is actually only 90 miles from busy, bustling San Diego. Just east of San Diego County's coastal mountain range lies the 650,000 acres of desert wildlands known as Anza-Borrego Desert State Park.

This Park is home to some of the most exotic plants and animals in the world and offers recreation opportunities ranging from a casual few-hour visit to a lifetime of exploration and adventure. The loneliness of Anza-Borrego satisfies the yearning of our hearts, bringing the gentle peace that comes from being in a place where you can be alone with beauty.

Anza-Borrego can also satisfy those who seek the romance of the Wild West, with its lost gold mines, haunted places, old stage routes, hidden palm oases, mysterious trails, and the priceless sight of the things left behind by the nomadic native inhabitants of this arid land.

First-time travelers passing through may view the desert as simply a wasteland of rocks, unfriendly vegetation, and sand. But the visitor who is willing to spend time and explore Anza-Borrego will soon be unable to stay away for very long. There is a lifetime of wonder, exploration, and discovery to be found in the arid canyons, vast open plains, and boulder piles of this unique place.

Anza-Borrego is not a place you can visit in a day, or even a week, and say you have seen it. The terrain varies from mountains nearly 6,000 feet in elevation and covered with pines and oak trees, to barren badlands contorted and wrinkled like the skin of an old iguana. There are slot canyons hundreds of feet deep and barely wide enough to walk through, sand dunes painted by the wind with delicate ripples, cactus gardens of untold beauty during spring wildflower blooms, and majestic bighorn sheep standing like movie props on the rugged rocks.

Thunderstorms can create flash floods and turn a scorching summer day into a humid steam bath, but a gentle winter sun can warm the coastal visitor who passes through rain and snow on the drive from the city. This is a place to be experienced over time, a place to explore, a place to wander where you wish, marveling at the grandeur. This is a place for forever.

The first-time visitor to Anza-Borrego should make their first stop at the Park's Visitor Center at the western edge of Borrego Springs. The Visitor Center offers maps, displays of some of the many natural and historic wonders of the region, and a staff of volunteers and park employees who can answer questions.

October 1st is considered the start of the "desert season," when searing summer temperatures have moderated and the crowds seeking the wonders of this arid land return to hike, camp, explore, study the fascinating geology, photograph wildlife, take a car tour, or simply bask in mild winter sunshine and watch Nature's palette change colors from sunrise to sunset.

Winter rains, if timed right, can produce a spring bloom of wildflowers that is nothing short of inspirational. There are flowers every year, but a spectacular bloom happens only when there is adequate rainfall, a period of mild temperatures, and no wilting winds. When these perfect conditions are met, visitors to Anza-Borrego can view vast fields of purple verbena, ocotillo forests sporting brilliant red blossoms, showy white dune primrose, and cheery yellow brittlebush decorating desert roadsides.

The annual wildflower show is one of the biggest attractions to Anza-Borrego, but there is so much more for the adventurous and inquisitive. There is history here, from prehistoric Indian inhabitants who left petroglyphs carved in the rocks, to early explorers and pioneers who endured the desert extremes in search of new lands. Juan Bautista de Anza entered the new world en route from Mexico to colonize what became San Francisco, passing through here first in 1774.

County Road S-2, the route of the Southern Emigrant Trail and the Butterfield Overland Mail, crosses the southern portion of the Park. From Scissors Crossing on Highway 78 to the junction of Interstate 8 at Ocotillo, modern visitors see a landscape that has not changed since hardy travelers were pulled by a team of horses in a rickety stagecoach heading for San Francisco 150 years ago.

Follow a rugged desert road to a remote palm oasis where it would be easy to imagine camels and nomads camped close by, or stand on Fonts Point at sunrise and marvel at a scene that can only be experienced and never adequately described.

For the adventurous there are over 500 miles of dirt roads, some requiring 4-wheel-drive vehicles. These roads lead to wild places where visitors can camp where they wish, enjoy the solitude, a moonlight visit from a desert kit fox, and a spectacular desert sunrise or sunset.

There are more than a half million acres in Anza-Borrego awaiting your exploration. Spend some time, let the sand get in your shoes, and learn the desert's little ways. For more than 40 years I have been able to do this, and much of my journey has been recorded by my camera. I hope you will enjoy sharing it with me.

Ernie Cowan

ACKNOWLEDGMENTS

FOR MORE THAN 40 YEARS, I've had a love affair with Anza-Borrego Desert State Park. As a young Boy Scout I can remember bouncing along a dirt road in the back of a truck on our way to a campsite in Borrego Palm Canyon. You could do that in those days. That night we were filled with wonder at the sight of the Russian "Sputnik" satellite slowly crossing the inky desert sky.

When I was old enough to drive, I spent every available weekend and school holiday in the desert. With friends we hiked, camped, and explored every trail we could follow. I became a journalist and eventually my "beat" included Anza-Borrego Desert State Park. Now I was being paid to wander the desert wilderness and write about the beautiful places I had visited.

I was impressed with the dedication of men like Wes Cater, Jim Whitehead, Bud Getty, Jack Hesemeyer, and Mark Jorgensen. They helped me see how important it is to preserve this unique place.

The effort to make this book happen could not have been successful without the help of many. Here is a list of those who became part of the team to make this journey possible:

For photo identification of critters and plants: Ranger Bob Thériault; Jim Dice, Senior Environmental Scientist for the Colorado Desert District, California State Parks; and Jon Rebman, Curator of Botany, and Michael Wall, Curator of Entomology, both from the San Diego Natural History Museum.

Ranger Steve Bier for his sense of humor and enthusiasm.

Ranger/pilot Kelly McCague for providing me with a bird's eye view.

Jenan Saunders and Brian Cahill for supplying the California State Park logo.

Mark Jorgensen, Superintendent of Anza-Borrego Desert State Park, a true friend and source of inspiration to me. Without his help I would have been really stuck.

The Board of Trustees of the Anza-Borrego Foundation and Institute, for initial photo selection and support of this project.

Book designer Kathleen Wise.

Sunbelt Publications Editor-in-Chief Jennifer Redmond, whose skill and dedication added life and focus to my words.

There must be a special paragraph for Lowell and Diana Lindsay. We have shared a mutual love of the desert and our paths have crossed in Anza-Borrego many times. Diana's enthusiasm for the desert is unmatched and her ability to make things happen came to play in making this book a reality.

And finally to my beautiful wife Kati: She taught me to write from the heart and give feeling and life to my words, not just a cold journalistic style. We have shared many beauties in the desert and our journey will continue for many more years. We are off to see the Wizard.

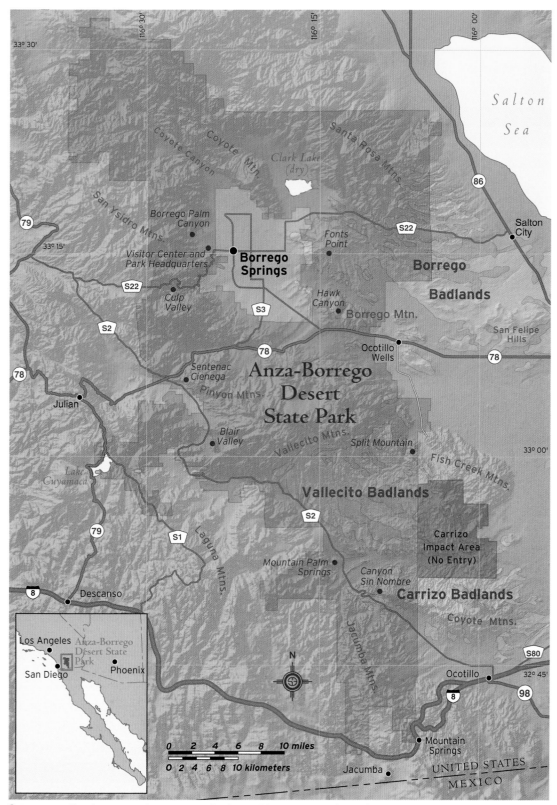

33° 30'

116° 30'

116° 15'

116° 00'

Salton Sea

Coyote Mtn.

Coyote Canyon

Clark Lake (dry)

Santa Rosa Mtns.

86

San Ysidro Mtns.

Borrego Palm Canyon

79

33° 15'

Salton City

S22

Fonts Point

Borrego Springs

Visitor Center and Park Headquarters

Borrego Badlands

S22

Culp Valley

S3

Hawk Canyon

Borrego Mtn.

S2

78

Ocotillo Wells

San Felipe Hills

78

Sentenac Cienega

Anza-Borrego Desert State Park

Pinyon Mtns.

Julian

Blair Valley

Vallecito Mtns.

Split Mountain

33° 00'

Lake Cuyamaca

Fish Creek Mtns.

Vallecito Badlands

S2

Carrizo Impact Area (No Entry)

79

S1

Mountain Palm Springs

Canyon Sin Nombre

Carrizo Badlands

Laguna Mtns.

8

Descanso

Coyote Mtns.

S80

Los Angeles

Anza-Borrego Desert State Park

Phoenix

San Diego

N

Ocotillo

32° 45'

8

98

Jacumba Mtns.

Mountain Springs

0 2 4 6 8 10 miles

0 2 4 6 8 10 kilometers

Jacumba

UNITED STATES

MEXICO

© 2008 Lowell and Diana Lindsay. Cartography digitized by Ben Pease, adapted from L. Louise Jee, California State Parks.

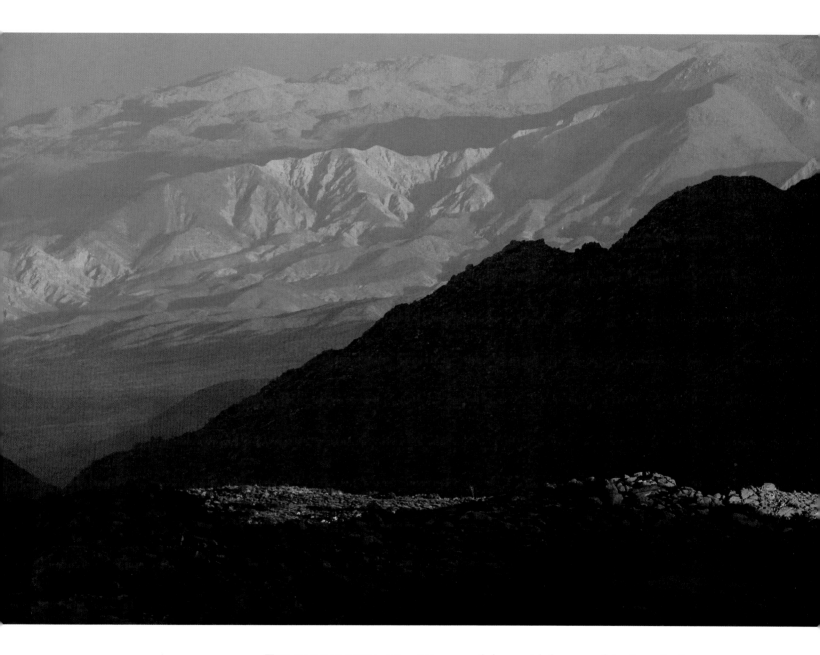

THE FADING HUES OF SUNSET reveal the special character of the desert landscape.
The low angle casts a glow that brings to life the subtle elevation differences that one never
sees in the bright light of midday. Tucked into the arms of the San Ysidro Mountains,
Culp Valley is covered by evening shadows while the distant Vallecito range takes on the
warm glow of evening light.

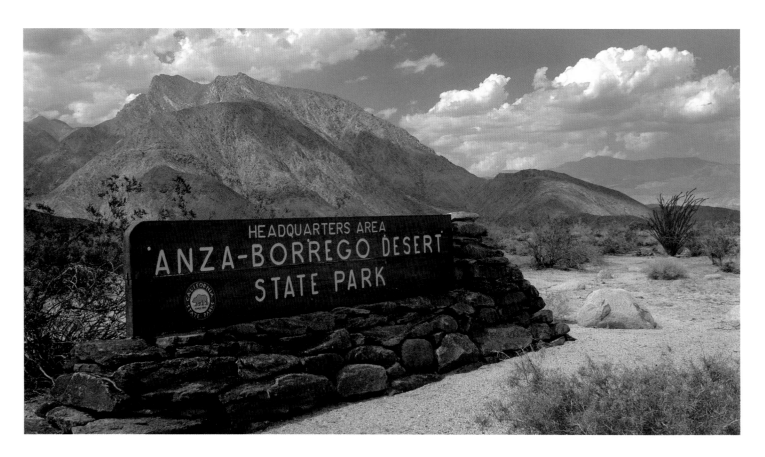

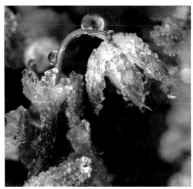

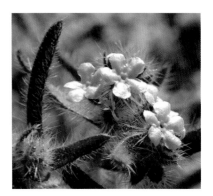

THE FORESIGHT OF MANY PEOPLE helped create Anza-Borrego Desert State Park, and the hard work and dedication of a few today maintains and protects this unique and beautiful environment for all to enjoy. Not only is this the largest state park in California, it is undoubtedly the most diverse, ranging from the arid sands of the hottest desert to high meadows and pine-clad heights.

WITHERED BY SUMMER HEAT and now encrusted in ice from a mid-winter freeze, the remnants of a phacelia flower provide the visitor a glistening display that lasts only a few hours until a warming sun melts away the frost. Subtle beauty such as this awaits those who patiently explore and carefully observe.

AN EARLY FROST on the tiny blossoms of the popcorn flower evaporates with the morning sun. Many events in the desert are brief but beautiful and only seen by visitors willing to spend the odd hours of all seasons in search of Nature's treasures.

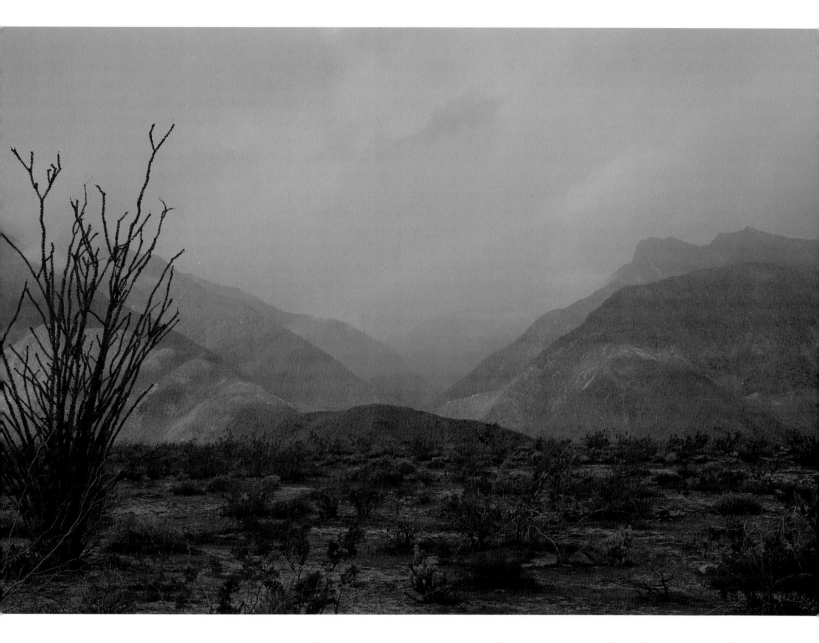

A COLD WINTER STORM brings beauty to the desert. Rain alone is not enough to stimulate the growth of spring wildflowers, but for the moment, it combines with a ray of sunshine to produce a rainbow and the hope of a magical spring. If enough rain falls at the right time, the colors of the rainbow will be echoed across the desert landscape by a brilliant display of yellow, red, blue, and purple blossoms.

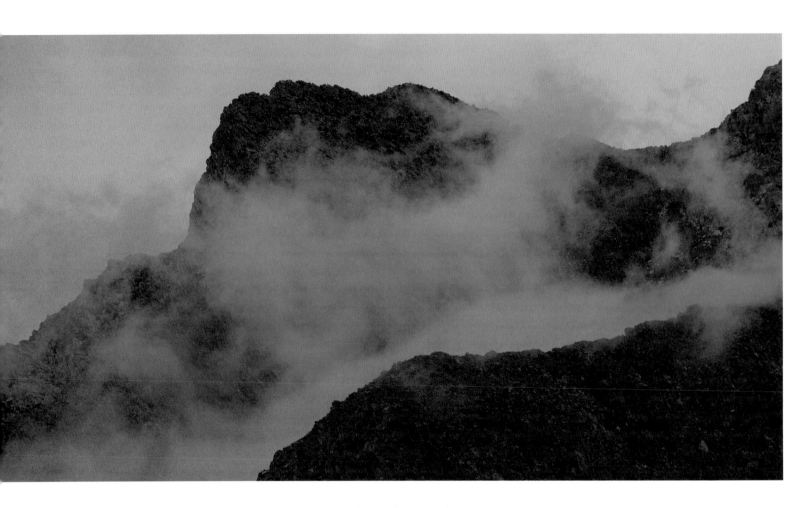

LIKE AN ETERNAL SENTINEL the granite heights of Indianhead stand
guard over the western edge of Borrego Valley—often reflecting the moods
of the desert. Here the cold clouds of a winter storm swirl around the
landmark as rain spills from the mountains to the west.

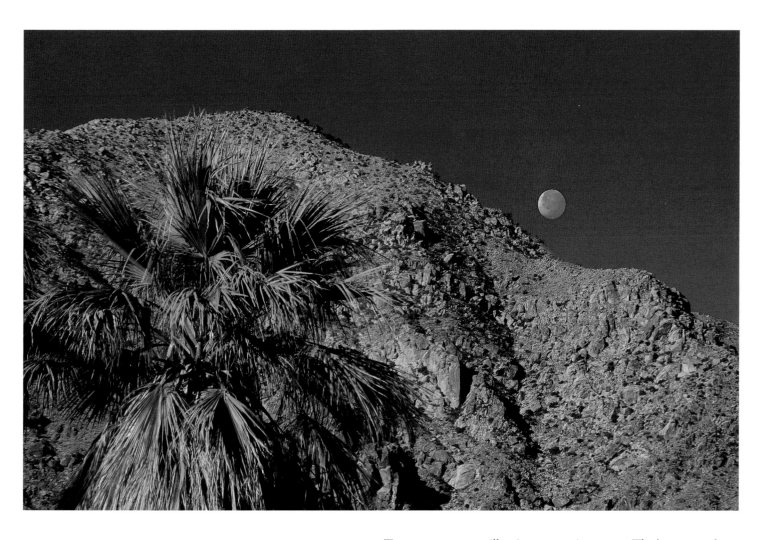

THE RISING SUN illuminates a setting moon. The barren, stark, and rugged mountains of the San Ysidro range tower high over the palm groves that offer shade, comfort, and protection from the hot sun in Borrego Palm Canyon.

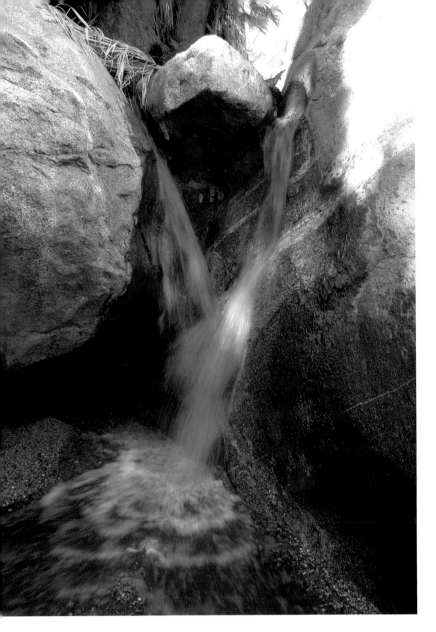

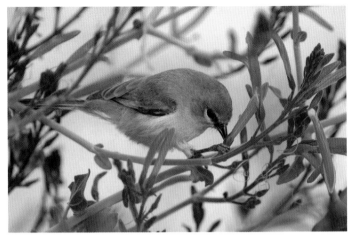

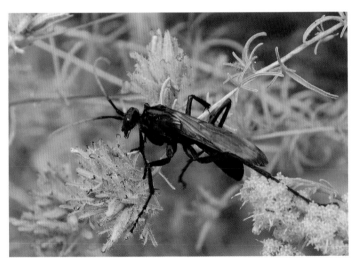

THERE ARE SUCH CONTRASTS in the desert. Arid slopes covered with cactus and ocotillo, mud hills seemingly devoid of life, sand dunes dotted with just a few hardy plants. But tucked into the deep canyons of the western slopes are streams and pools that provide the water needed by bighorn sheep, deer, and a host of other species who have adapted to this arid environment.

A TINY VERDIN is nearly lost in the blazing clusters of chuparosa blossoms as it grasps a flower and feeds on the tiny drops of nectar deep in the throat of the bloom. An abundant spring's bounty brings the desert alive with insects, birds, and animals.

THE DISTINCTIVE RED WINGS of the large tarantula hawk and the deep drone of its wing beats makes it easy to know when this wasp is nearby. To hatch their young, the wasp paralyzes a tarantula with its sting and then lays eggs on the host spider, providing a source of live food when the wasp larvae hatch.

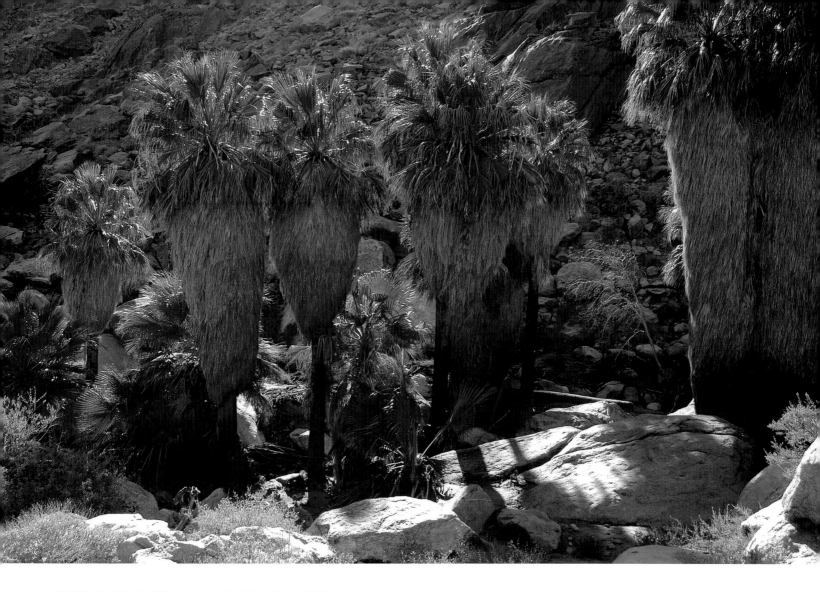

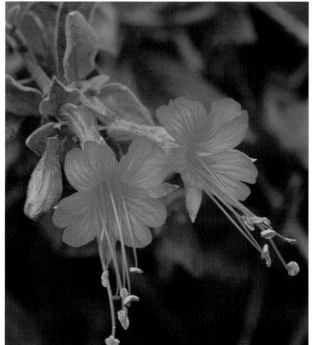

THE ISOLATED PALM GROVES that dot the canyons of Anza-Borrego provide food and shelter for a wide variety of life forms. These redwoods of the desert are often hidden in remote places but provide a worthwhile and attractive destination for hikers and wildlife alike.

BRILLIANTLY COLORED AND DELICATE, the flowers of the desert fuchsia blaze with an invitation to hummingbirds or passing insects to sample their nectar and spread their pollen. Tucked into the moist, shaded nooks of Borrego Palm Canyon, these beautiful flowers await discovery.

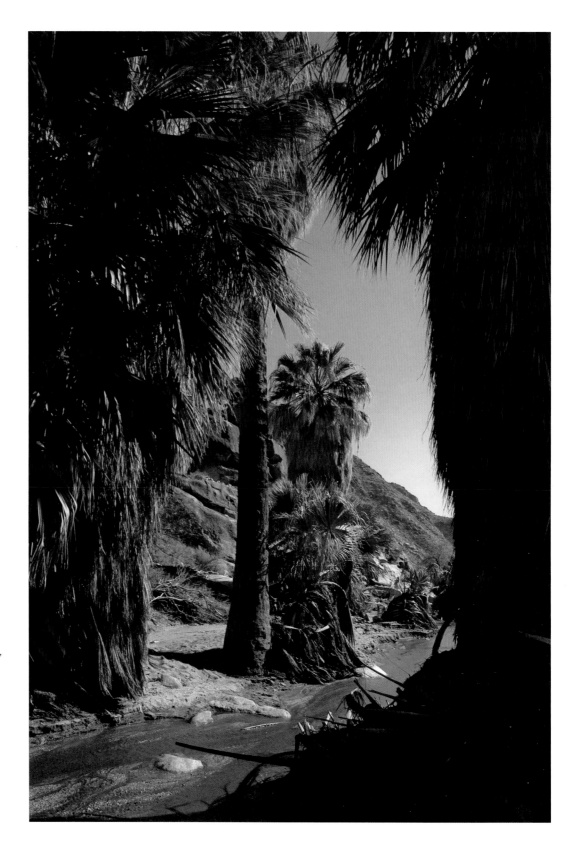

WHERE THERE ARE PALMS, there is water. The palm groves are a gathering place for many species that depend on these oases for survival during the sweltering months of summer. In the cool shade of the palm trees, silent visitors may hear the sounds of insects, birds, and frogs.

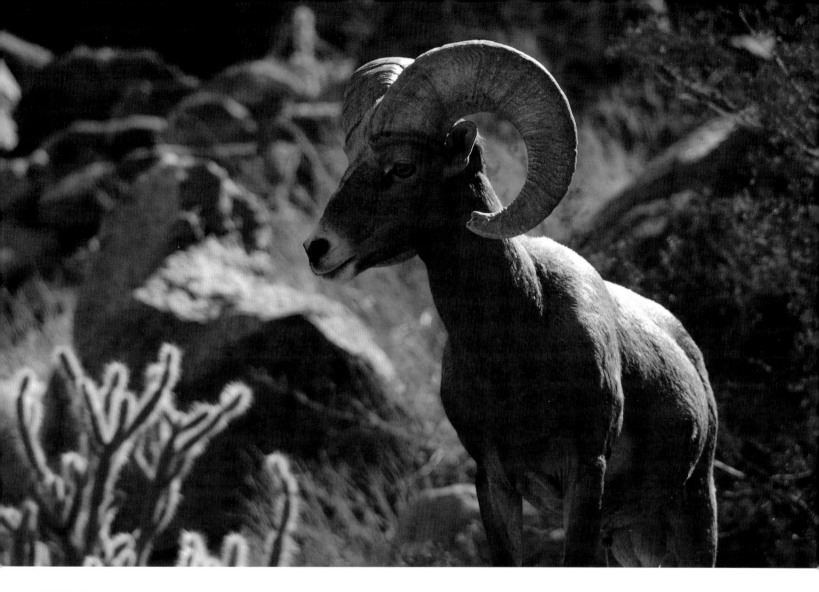

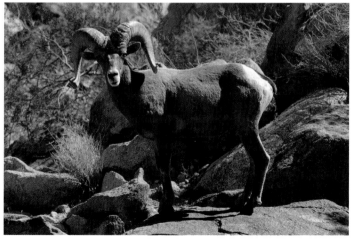

WHERE THERE IS WATER, there is life, including this massive bighorn ram in Borrego Palm Canyon. In late summer, dwindling water sources and the drive of the mating instinct bring bighorn rams and ewes into the palm groves together until winter rains allow them to separate and spread out once again.

THIS MAJESTIC RAM seems unconcerned that another visitor shares his domain. With an estimated population of only a few hundred, the desert bighorn sheep is fully protected. A hike to a remote palm grove in the peak of summer will often reward the desert visitor with a sheep encounter; their grace and beauty make them a memorable sight.

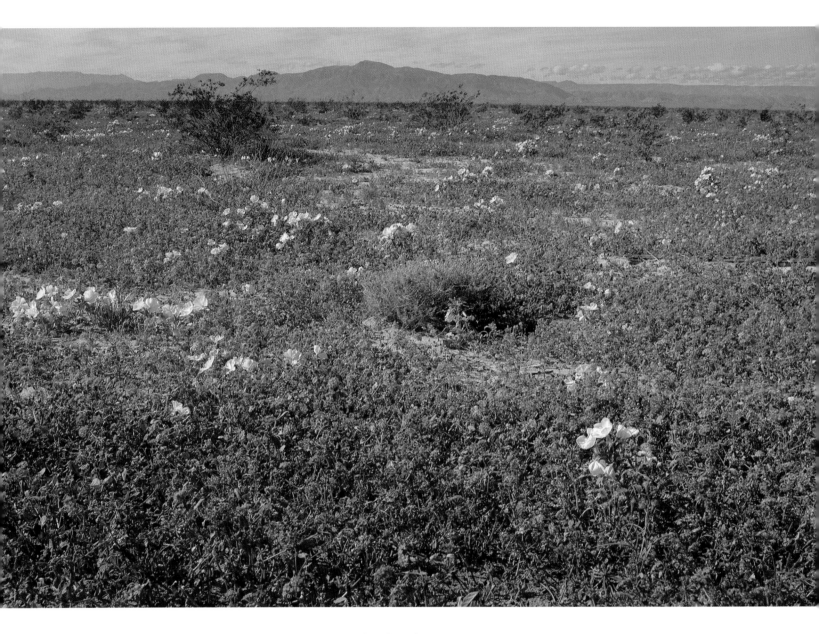

FROM A DISTANCE the spring sands may appear lavender when that rare combination of rainfall, temperature, and soft winds combine to allow a mass of verbena to grow and carpet the normally barren landscape. Each spring there is hope for another brilliant display, but the desert veteran knows that it is this beauty's rarity that makes it even more spectacular.

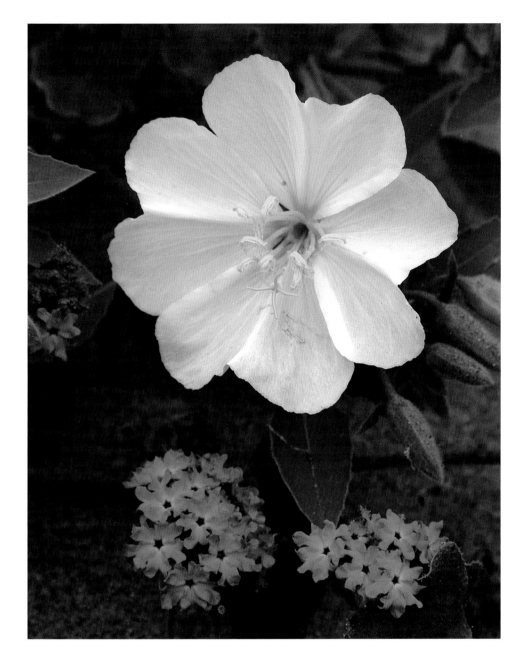

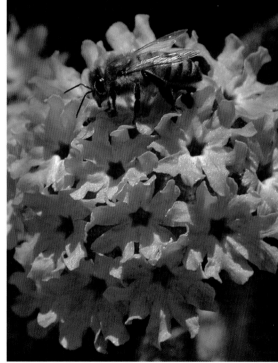

SOME SPECIAL YEARS, the desert is transformed into a veritable kaleidoscope of color. Here, large white dune primrose and delicate lavender verbena bloom in sprawling fields of color. Often mixed with yellow desert sunflowers and blue lupines standing like candlesticks, these brilliant spring blossoms bring visitors to the desert in great numbers.

THE VIBRANT LAVENDER BLOSSOMS of the desert verbena often cover vast areas of the desert when late winter rains have triggered a spring bloom. An abundant spring brings a cycle of plenty to the desert, with many insects and small animals feeding on the plants, birds feeding on the insects, and larger animals feeding on the birds and rodents that thrive during the spring feast.

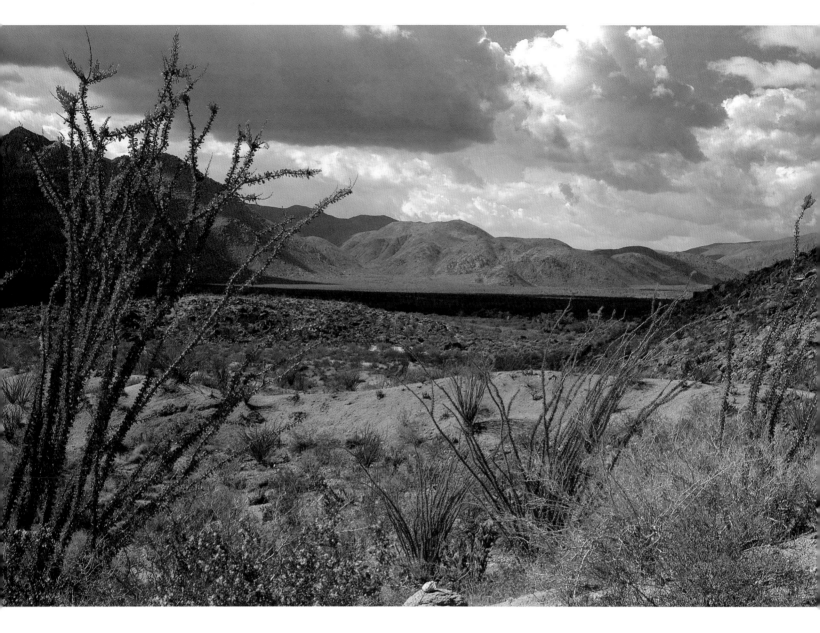

IN THE VAST, UNSPOILED MOUNTAINS AND VALLEYS of Anza-Borrego,
a visitor can spend days and not see another soul or the scars of man's industry.
The quiet lets you hear little things like a bird's wing beats or the buzz of feeding
insects in the brilliant red blossoms of a spring ocotillo, like this one, overlooking
Collins Valley in Coyote Canyon.

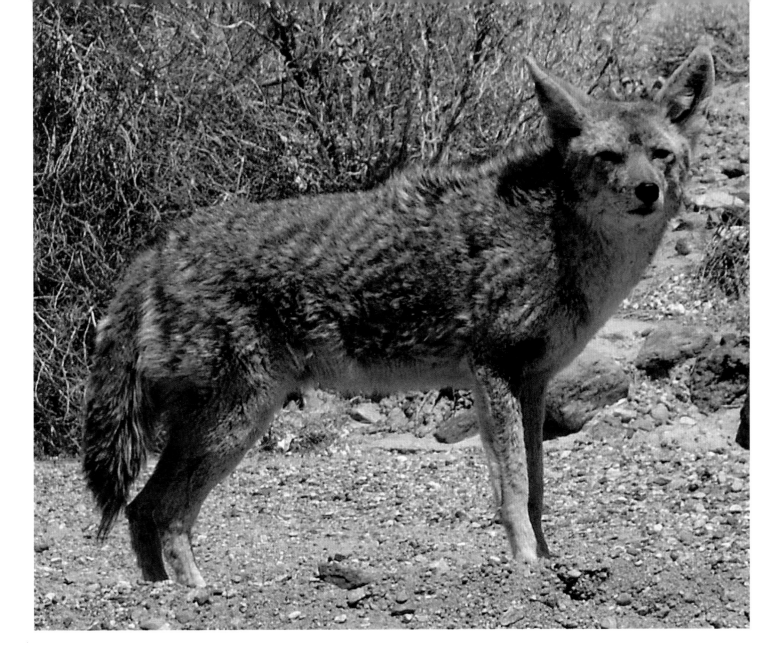

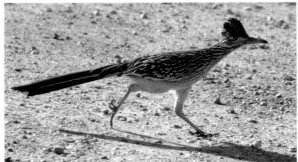

THE WILY DOG OF THE DESERT has adapted to this harsh environment well, learning to find food and water in a place that seems arid and lifeless. The sounds of the coyote often fill the night; they communicate in barks and howls to distant partners as they work together to hunt for food in mesquite thickets or near sparse water sources.

RARELY FLYING AND OFTEN RUNNING SWIFTLY ahead of hikers, roadrunners are members of the cuckoo family, distinguished by their X-shaped footprints. Curious and animated, roadrunners are a delight to observe as they bob and weave through underbrush in search of snakes, lizards, and insects.

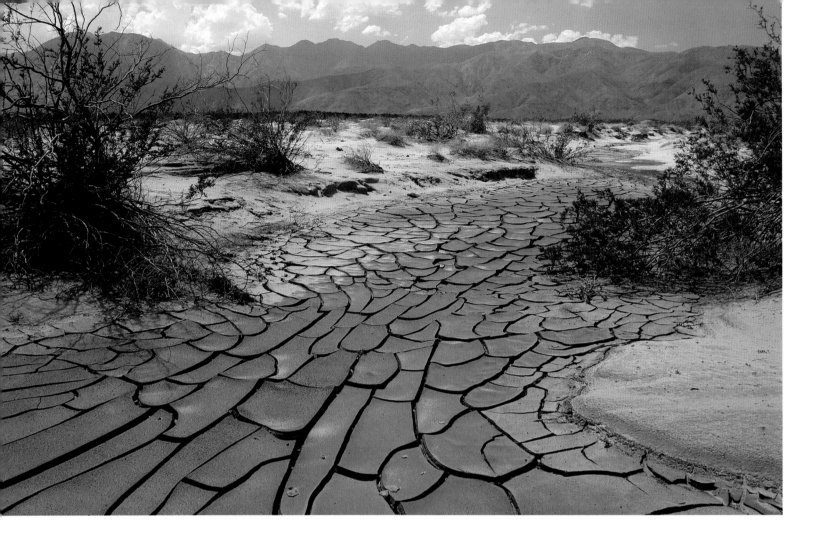

A TORRENT OF summer flash flood waters sweeping
down Coyote Canyon left behind a changed landscape.
Searing temperatures will soon provide a natural kiln to
fire the sculpted mud into delicate pottery with intricate
patterns, only to be dissolved again when the next rains
arrive. The passing of a coyote, bighorn sheep, or the
many tiny creatures who call the desert home may
be recorded in these plates.

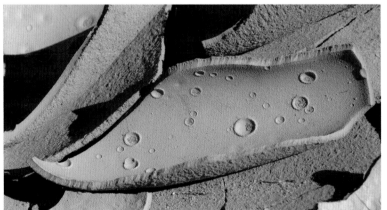

JUST A FEW DAYS BEFORE, this was a field of mud
created by flood waters from a rare desert rainstorm.
Now the curled plates of dried mud are pocked with
the preserved impressions of raindrops that fell while
the mud was still soft.

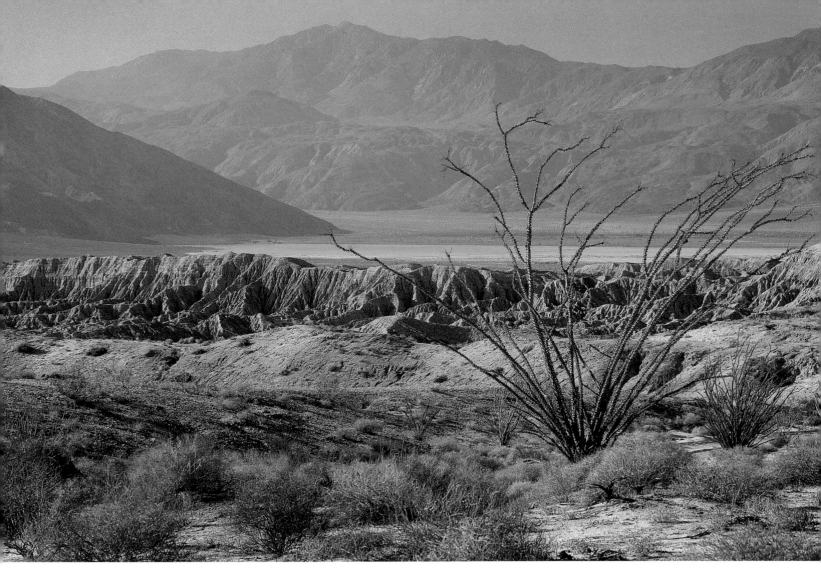

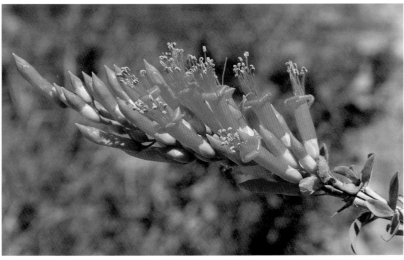

ANZA-BORREGO IS A PLACE where you can be alone with yourself, eternity, nature, and beauty. There is timeless solitude as you sit on a high point looking north across Clark Lake to the distant heights of Toro Peak. Views like this, that have not been altered by man, allow the mind to see what others have seen since the first footprints were scuffed into the desert sands.

FOR MOST OF THE YEAR, the whip-like ocotillo stands stark and menacing, often appearing dead. But after a spring rainstorm the plant is soon covered with green leaves and the tips of the branches are ablaze with bright red flowers and swarming with honey bees and hummingbirds.

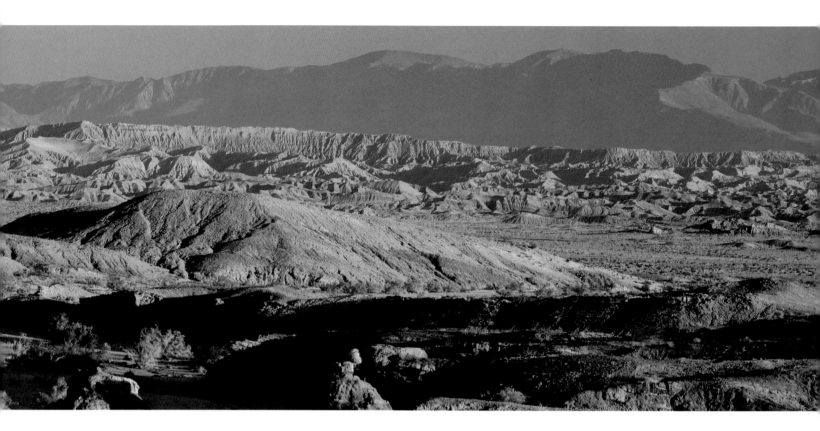

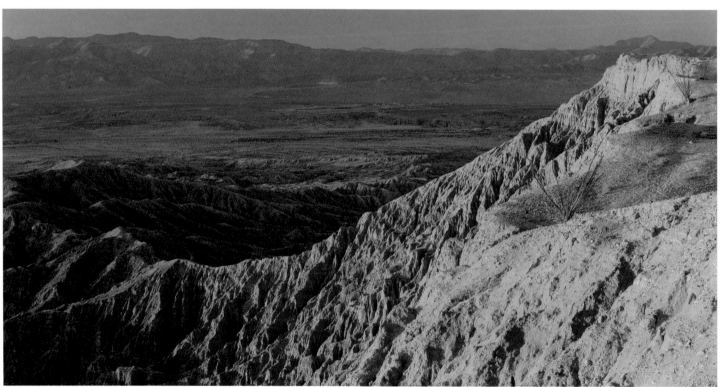

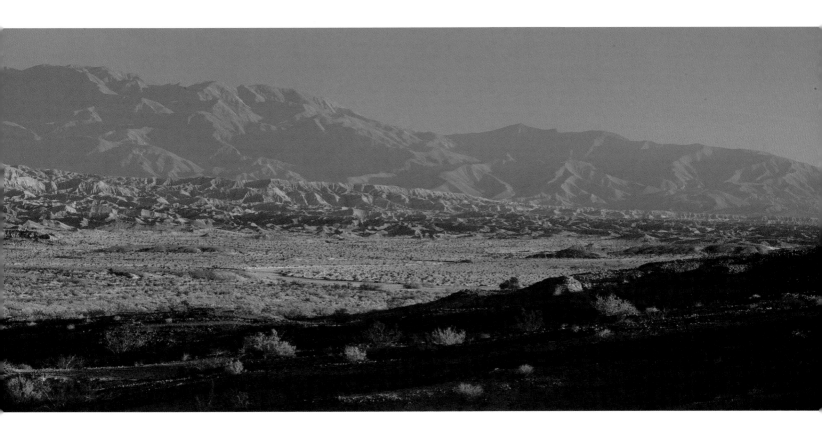

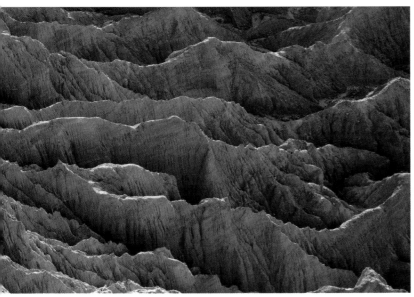

THE OCOTILLO RIM, with Fonts Point at its southwest edge, is a geological footnote to the more massive Santa Rosa Mountains to the north. The rim was formed when the sloping desert floor uplifted and tilted, creating a maze-like pattern of eroded canyons known as the Borrego Badlands. Both sunrise and sunset bring to light the broken terrain, with brilliant earth tones contrasted by the deep shadows of sculpted washes.

RISING MORE THAN A THOUSAND FEET from the desert floor, Fonts Point is the apex of the Ocotillo Rim and the first point to catch the warm red rays of a new day in the desert. A place of inspiration for many, Fonts Point has drawn untold numbers to share sunrises or sunsets, even to exchange wedding vows. Few visit this special place without being affected in some way.

THE DESERT IS RARELY SUBTLE. Temperatures can be extreme, winds can drive sand into the smallest openings, rainfall can be non-existent for years and then torrential for hours; a desert night is often a blind darkness, soon followed by the brilliant illumination of a full moon. The geological forces of wind and water are most evident in places like the Borrego Badlands where the sandstone formations have been carved into an impassable maze of narrow ridges.

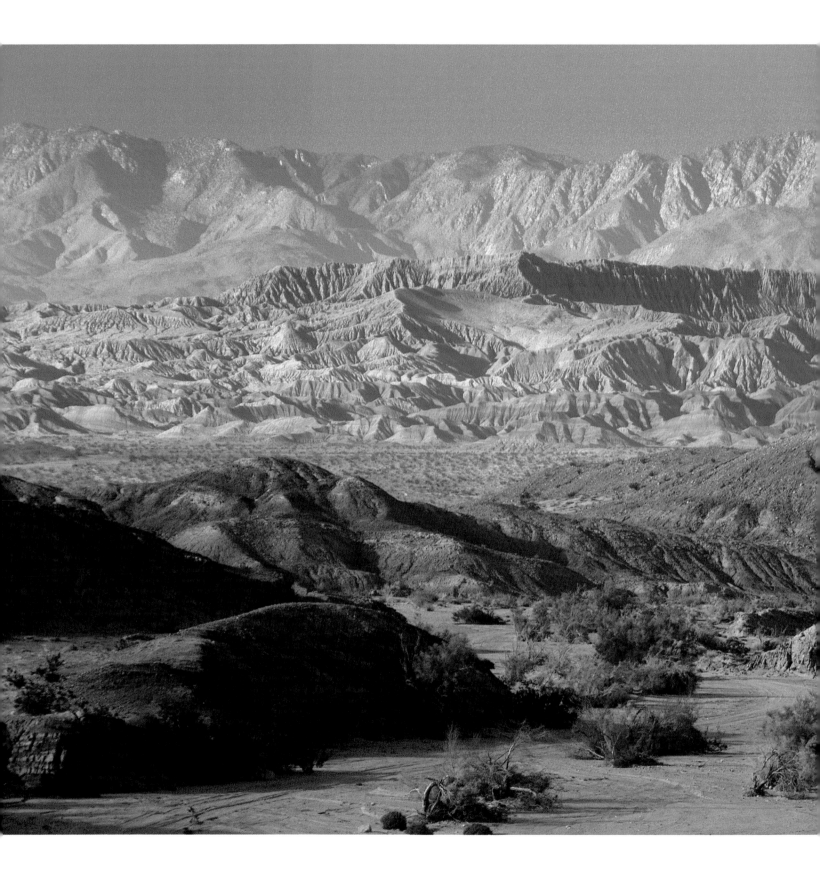

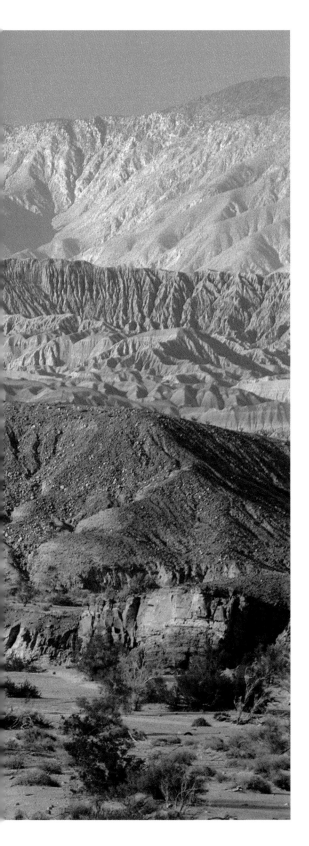

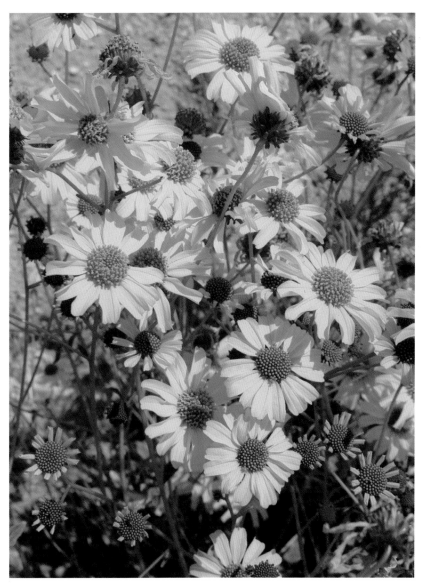

THE DESERT VISITOR who never leaves the highways will miss the incredible views that are a trademark of Anza-Borrego Desert State Park. Its vast expanses, unbroken by power lines, highways, or buildings, allow one to absorb the pristine beauty of the desert. In this view north from Borrego Mountain Wash, Fonts Point catches the late afternoon sunlight as the escarpment of the Ocotillo Rim gathers the shadows of evening.

IF THERE IS ONE FLOWER that might be considered the "Desert Greeter" it would be the brittlebush. One of the first to bloom in the spring, this showy shrub with gray-green leaves is found from the rocky western mountain slopes bordering the lower deserts to the eastern badland washes.

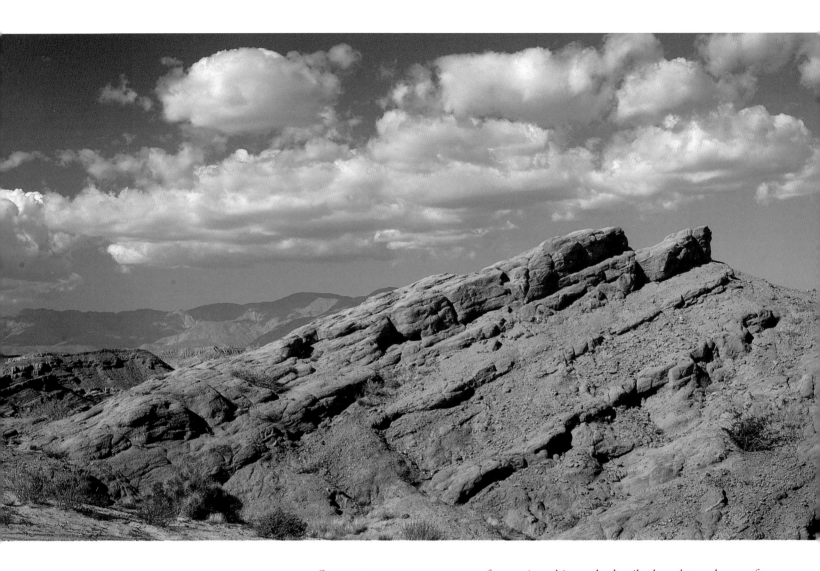

STANDING LIKE THE BOW of an ancient shipwreck, the tilted sandstone layers of the Borrego Badlands offer a starkly beautiful contrast to a cloud-studded indigo sky on a crisp spring morning. While many lovely vistas can be seen from the dirt roads of the desert, the real hidden beauty is found by those willing to explore on foot.

WITH DESCRIPTIVE NAMES like "Fat Man's Misery," "The Squeeze," and "The Slot," the sandstone cliffs in many areas of Anza-Borrego are eroded into narrow slot canyons. The shadowed light that reflects off of the canyon walls accentuates the sensual curves or towering cliffs decorated with mud drippings from rare rainstorms. The protected alcoves of the slot canyons also offer refuge for nesting birds and owls.

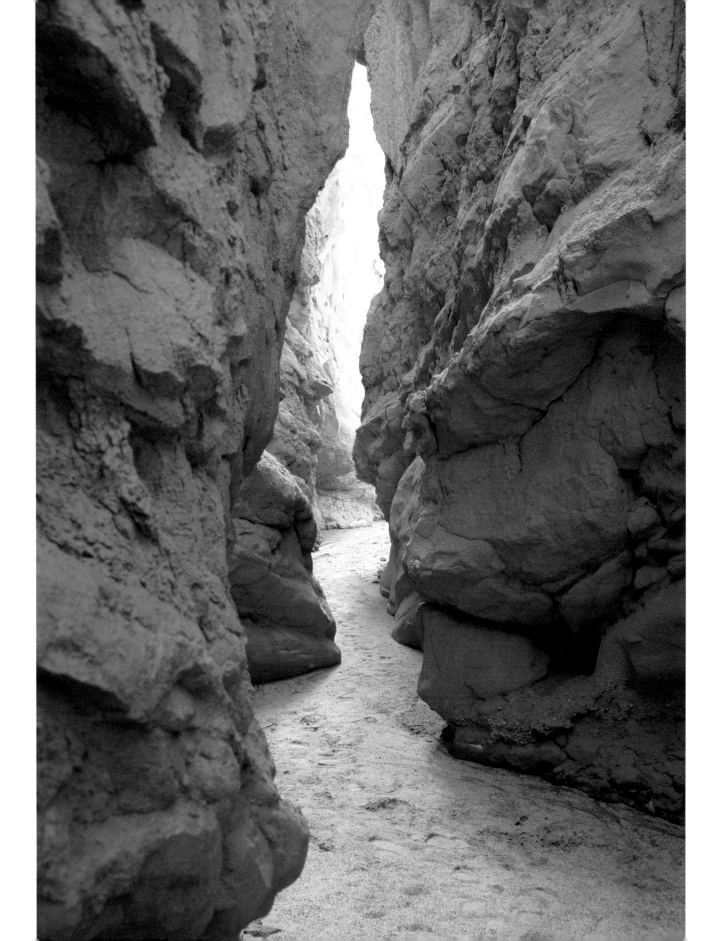

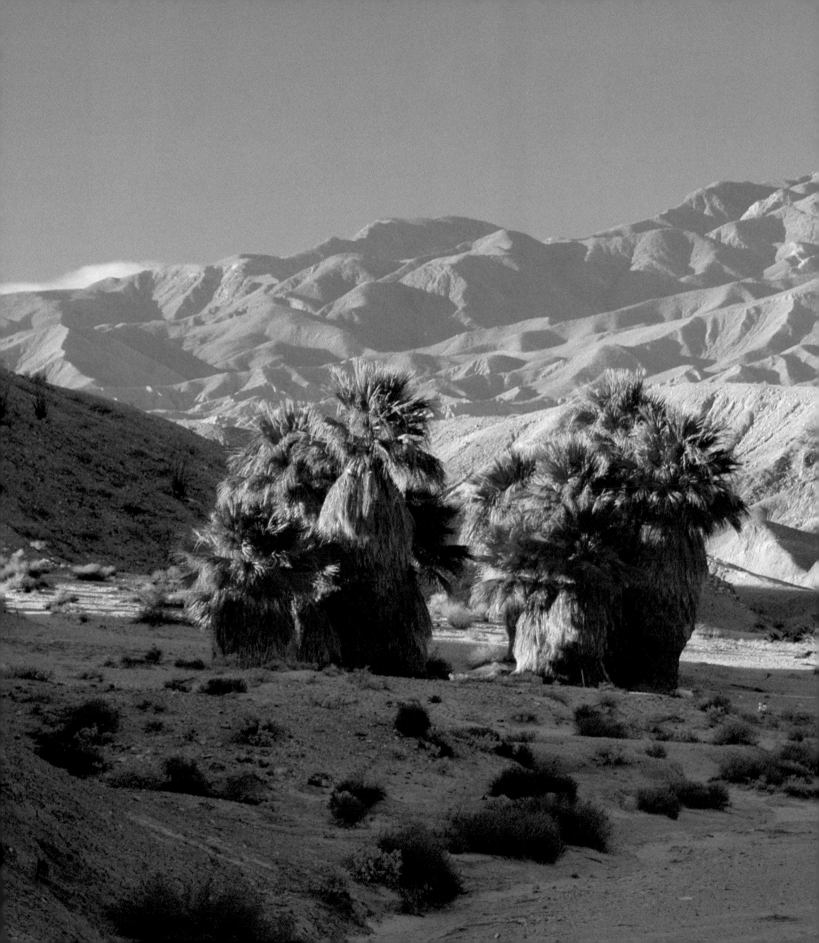

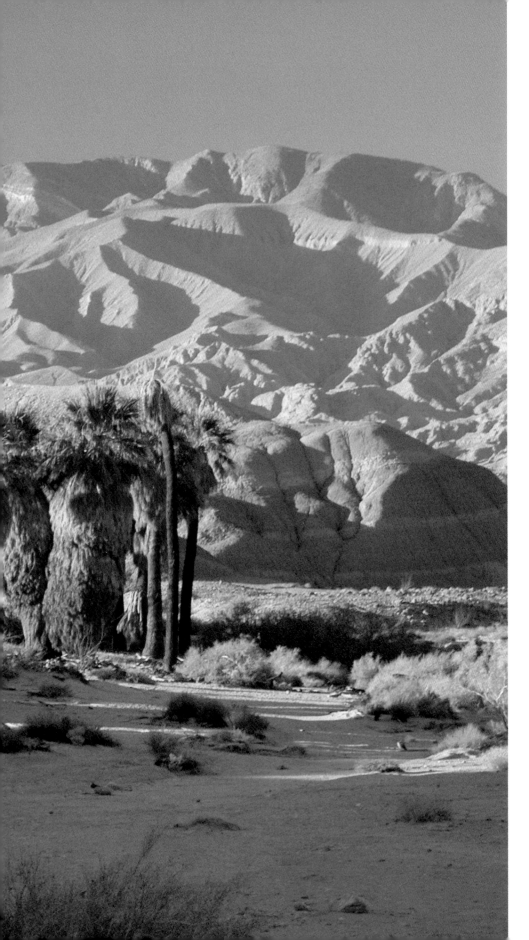

LIKE A MYTHICAL MIRAGE, 17 Palms Oasis is surrounded by a barren landscape — it suddenly appears as one wanders in road-less terrain at the foot of the Santa Rosa Mountains. Isolated along a pioneer travel route, the oasis once served as a rural mail way station where travelers would leave letters and notes in a wooden barrel for others to carry on to their final destinations.

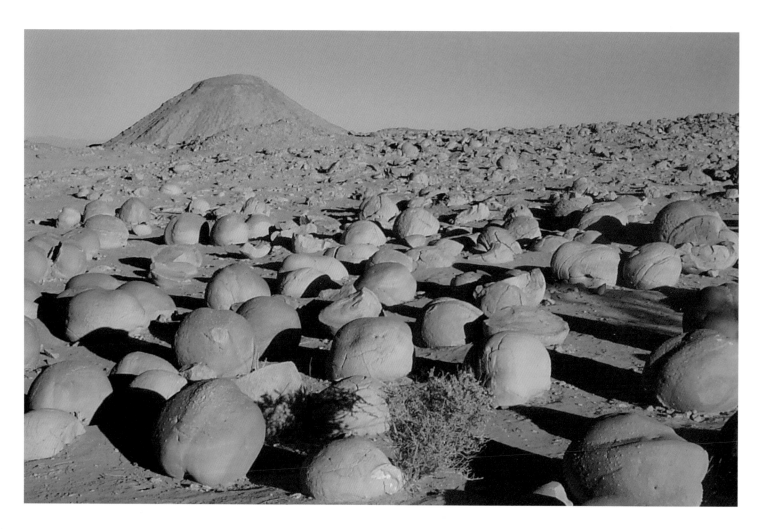

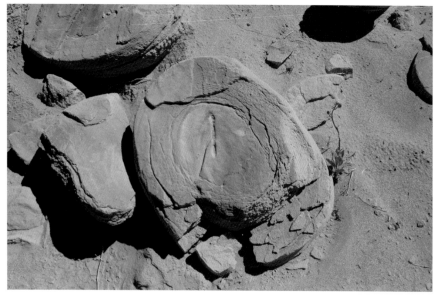

SANDSTONE FORMATIONS known as concretions stand like a petrified pumpkin patch in Tule Wash. Concretions are believed to have formed like pearls in an oyster, when sand particles attached to small objects and were cemented together by natural chemical bonding. Wind and water eroded the softer sand, leaving behind these unique globular formations.

THE LAYERS OF SANDSTONE that for thousands of years accumulated around the central core are visible in one of the "pumpkins" that has been split in half. Far from any paved road, the Pumpkin Patch is a popular destination for desert explorers in the western portions of Imperial County.

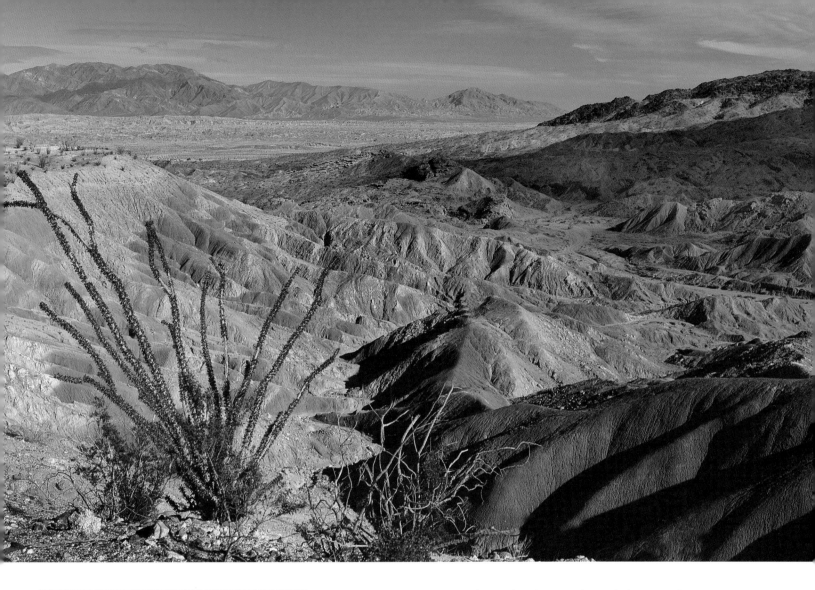

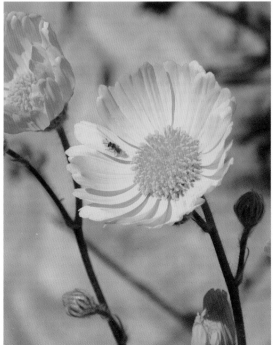

A LONE OCOTILLO stands guard at the top of a wash that cascades away into the carved and layered expanses of the Borrego Badlands. The terrain is a jumble of geological wonder, with exposed formations that tell the story of how the region was formed. Rich in fossil remains, the badlands have yielded the remains of long-extinct species and a glimpse into a time when the area was a verdant grassland with trees along its meandering streams.

THE DESERT SUNFLOWER tends to be solitary, but can grow in great numbers on flat, sandy plains. Often found with sand verbena and dune primrose, the sunflower will also bloom in the fall if blessed with late summer rainfall.

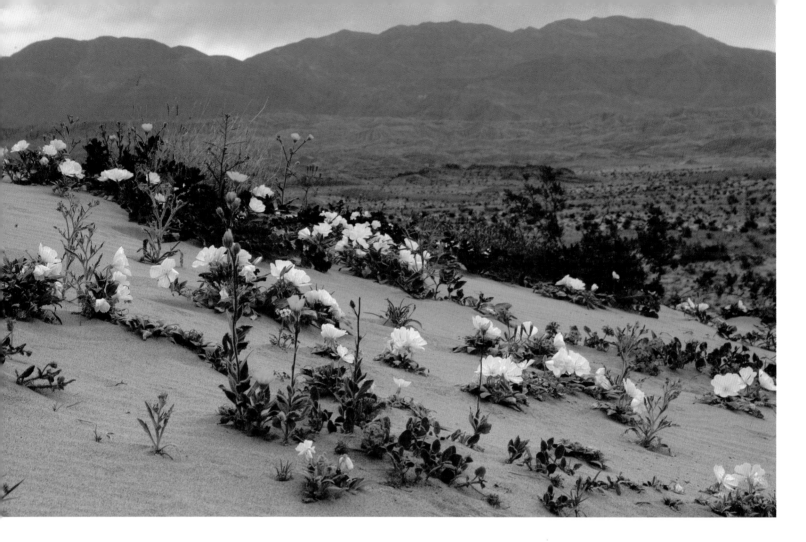

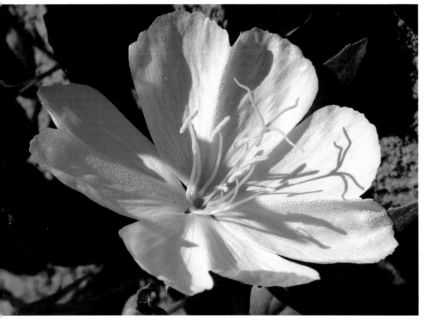

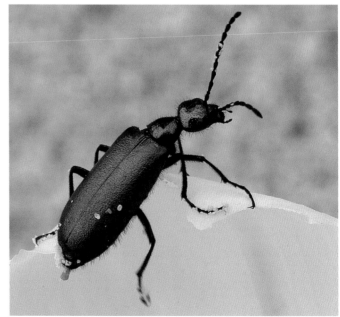

SOMETIMES FOR YEARS at a time, the gently rippled sand dunes of San Felipe Creek remain barren and seemingly devoid of life. But then a transformation occurs, bringing color and life to the shifting desert sands. The tiny plant communities spring up like boom towns and are populated with a diverse society of insects thriving in this short-lived season of plenty.

THERE IS SUCH CONTRAST between the blossoms of the dune primrose and the coarse sands of their harsh environment; so delicate that desert winds can wither and fade them in just a day, yet so hardy they thrive where no one would suspect anything could grow.

COVERED IN POLLEN, a bright green blister beetle clambers to the top of a dune primrose blossom in the rare abundance of spring.

WIND IS ONE OF the desert's greatest architects. Sandstone formations that have been uplifted by powerful geological forces are sculpted by occasional torrents of rain, but also by frequent desert winds. Water and wind-borne particles of sand help to slowly carve the sandstone into intricate formations known as wind caves. Wind caves are found at several places in Anza-Borrego.

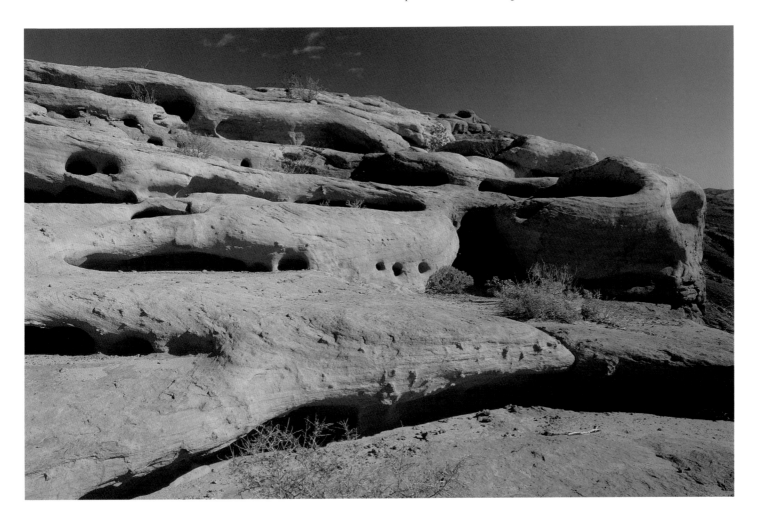

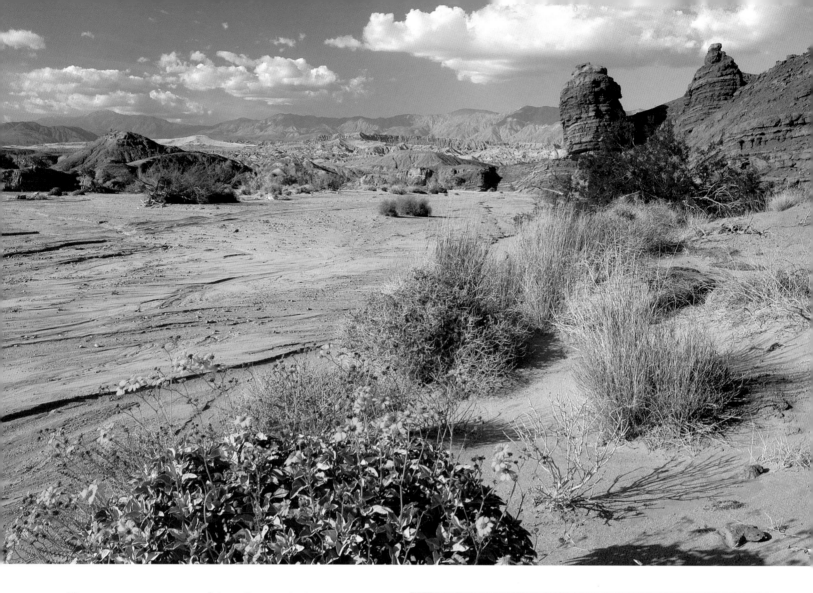

THE VAST EXPANSES of Anza-Borrego invite
exploration. There are few formal trails, but the basin and
bajada terrain is mostly open, with many wide washes and
frequent passages and winding canyons through its badlands.
There is isolation, but not loneliness as you wander through
places like Borrego Mountain Wash, especially when spring
flowers add to the beauty.

THERE ARE STORIES to be read almost everywhere in
the desert. The tracks of animals, the "trash" around a bird's
nest, or the circular pattern around a clump of grass. Recent
winds whipped the grass, sweeping away the dirt and telling
a story of erratic gusts from a spring storm.

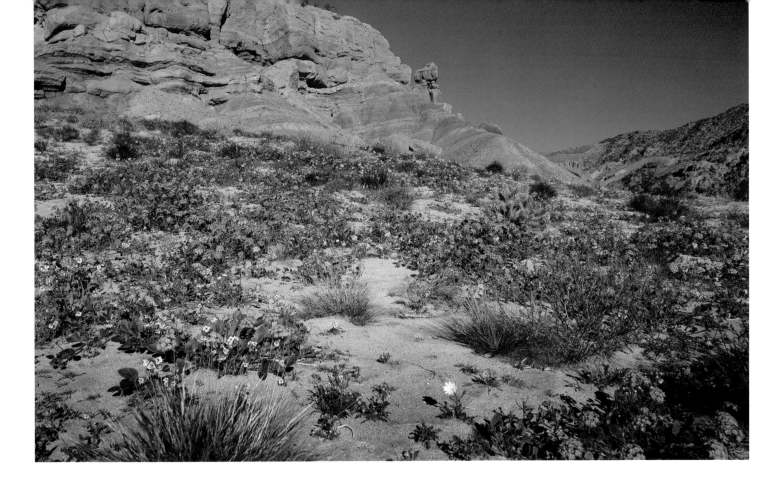

IN THE QUIET PASSAGES of Buttes Pass, a carpet of verbena climbs the sandy slopes that guard the entrance to Hawk Canyon. The normal buff, brown, and gray colors are accented with a variety and range of wildflowers that makes exploring the desert's hidden canyons a tantalizing adventure of discovery.

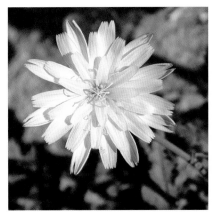

THE CONTRAST OF a dried, weathered piece of wood against the vibrant color of blooming sand verbena is a confirmation of the continuing cycle of life. In the blazing heat of summer, or after long periods of no rain, it may seem like life is gone from the desert. But a gentle winter rain will renew the soul and the spirit as well as nourish all of the living things here.

THERE ARE WILDFLOWER BLOOMS every year in the moist heights of mountain parks, but the harsh environment of the desert means that some years the sands remain barren. When conditions are right for a good bloom, the arrival of various flowers is like a reunion of old friends. The desert chicory is a member of the sunflower family and common to the sands of Anza-Borrego.

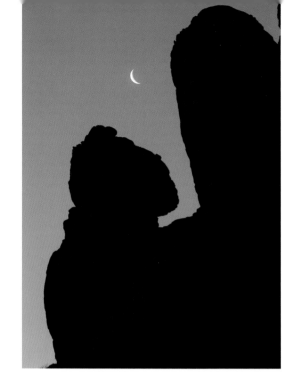

THE ROCK FORMATION of Hawk Canyon towers into the indigo sky as a crescent moon provides an almost mystic illumination. The soft moonlight provides just enough light to see, but not enough to clearly define the terrain. This allows your imagination to create images from the silhouetted rocks and plants. In the stillness of the night, there is comfort in the enclosing walls of this remote canyon.

THE DEEP, NARROW GORGE that cuts through the Fish Creek Mountains is known as Split Mountain. The sandy track of Fish Creek offers desert visitors a pathway through time as deposits from the ancient Colorado River Delta, alluvial deposits from primeval floods, and marine sediments from millions of years ago are all exposed to view.

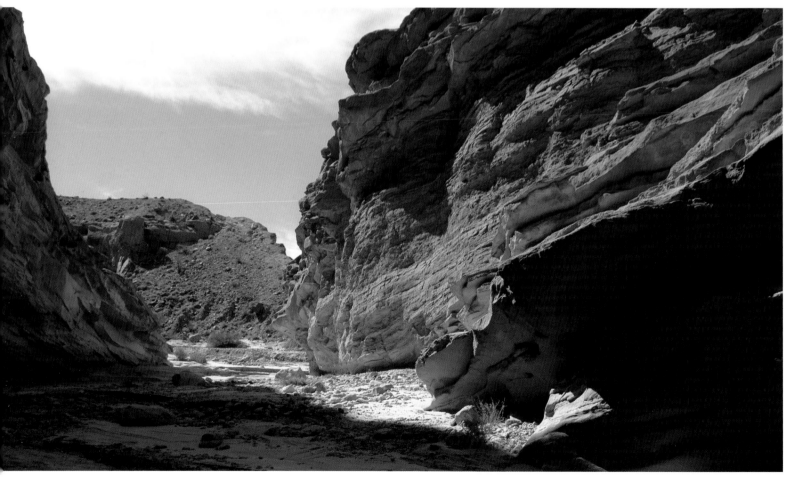

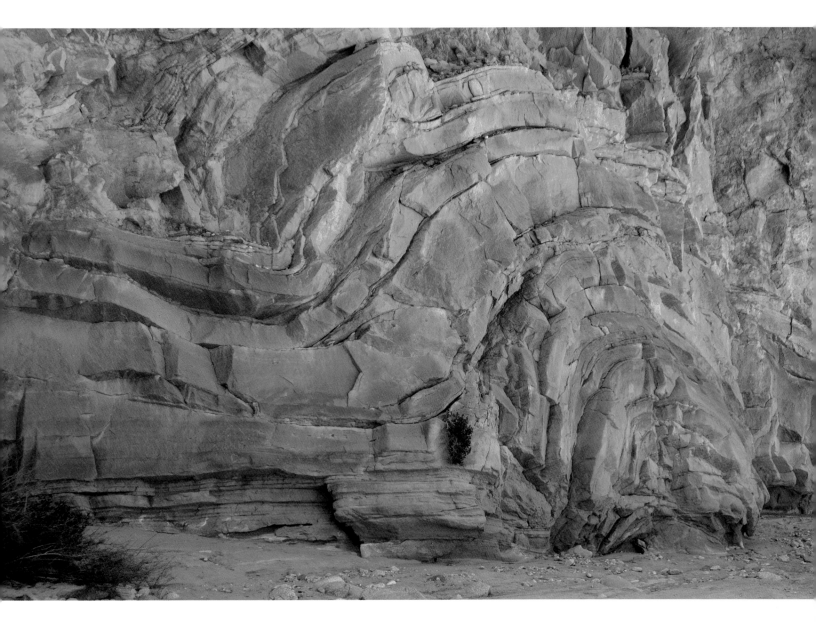

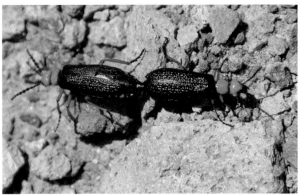

ABOUT FIVE MILLION YEARS AGO intense geologic forces and massive landslides folded the layers of marine sediment into this formation, known as an anticline. Fish Creek and the surrounding mud hills are a treasure trove of earth history, including fossil remains of the mammoths, early horses, and prehistoric camels that once roamed here.

SPRING IS A TIME for regeneration. This brightly colored beetle, called a master blister beetle, is just one of the many creatures that will thrive when spring rains bring ample food and new life.

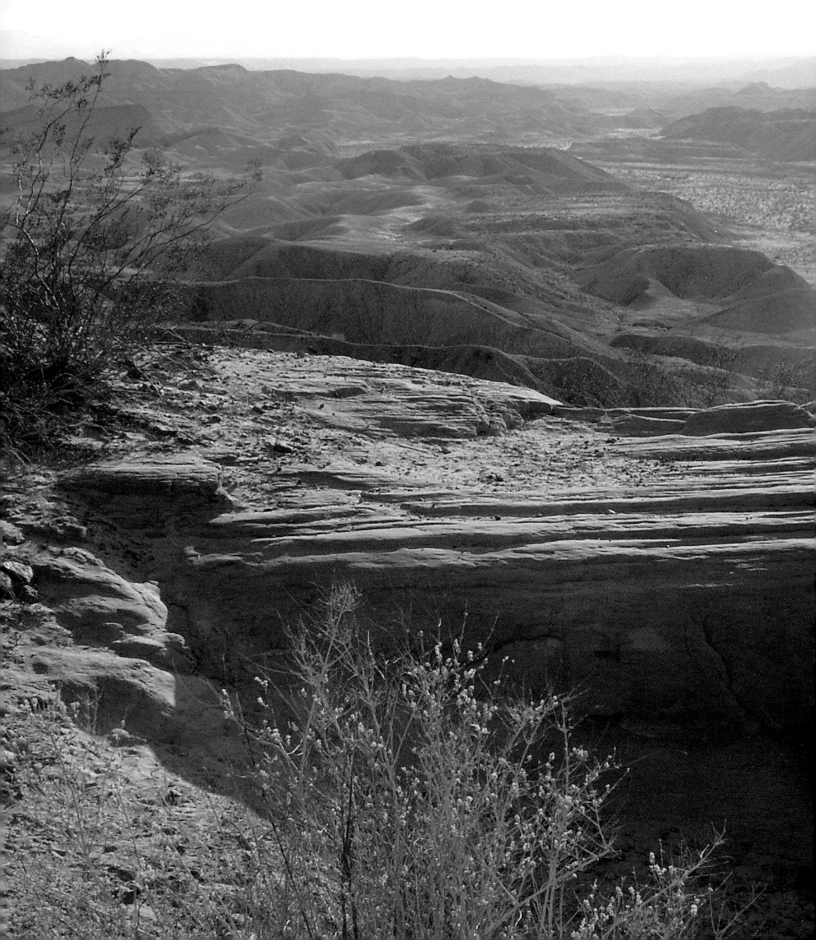

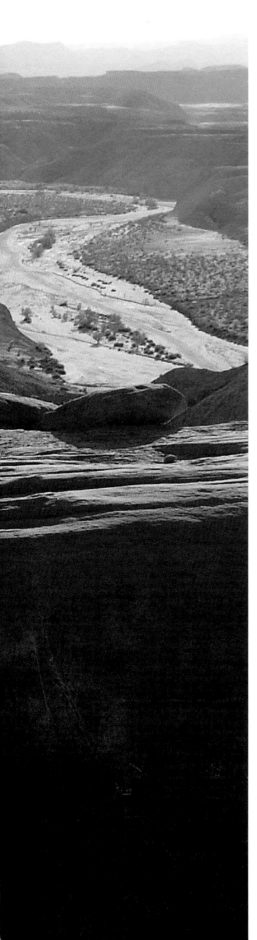

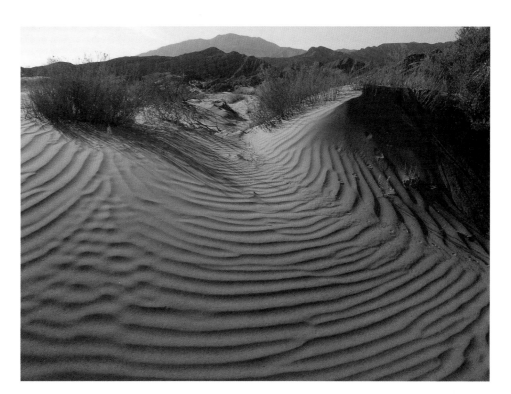

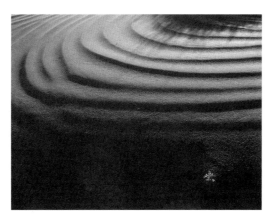

FROM THIS VANTAGE POINT above Fish Creek, it's difficult to imagine the scene as it would have appeared several million years ago. The massive sandstone beneath your feet was formed in an ancient sea. The terrain here is littered with the fossil remains of oyster shells and marine deposits left behind when the long-ago waters evaporated.

THE SAND DUNES in Loop Wash move with the shifting winds in an ever-changing pattern of ripples. The soft sand records the visits of the desert foxes, jack rabbits, snakes, lizards, and insects as they go about their solitary business. The early light of a new day accents the wind-created patterns, before desert winds sweep away the tracks from the previous day, leaving a fresh canvas for Nature's artwork.

PERHAPS THERE WAS a summer rain storm, or maybe only a few drops, but enough moisture was provided to allow a tiny plant to sprout in the rippled sands of Fish Creek. Within a few short weeks, the plant will grow, bloom, wither, and die as the moving sands are pushed by shifting winds or the rare torrent of a flash flood.

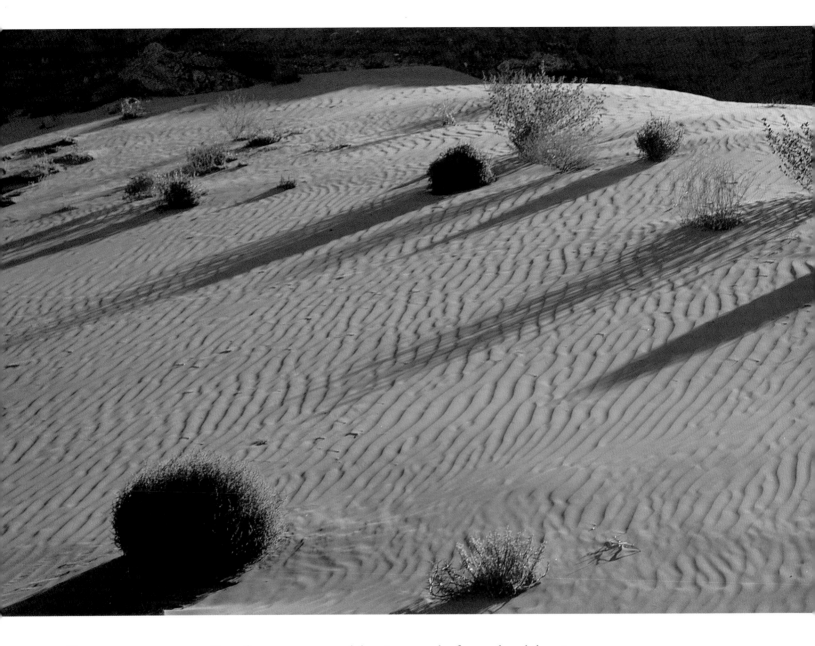

THE ANGULAR LIGHT of late afternoon turns a sand dune into a work of art as the subtle pattern of the ripples and shadows comes alive. To really know the desert, seek the subtle light of dawn or the vivid color of sunset. The desert is most alive when the denizens of the night first begin to prowl or seek their final forage before sunlight washes the landscape in the bright glow of the day.

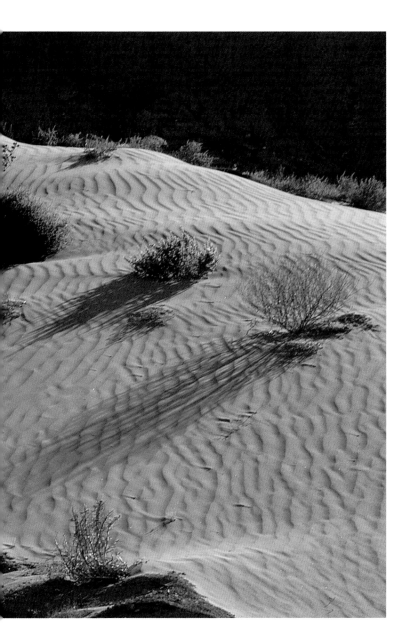

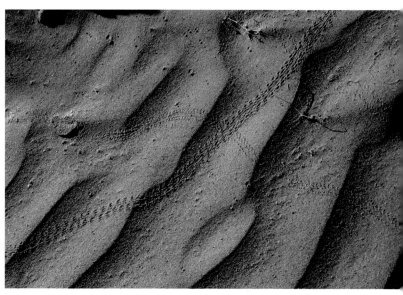

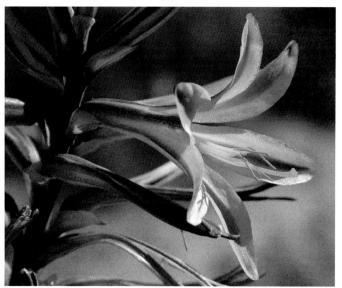

MANY PLACES IN ANZA-BORREGO allow the visitor to escape the signs of man's presence. Even short hikes from many of the trailheads lead to wilderness areas, unspoiled by the sight of man-made changes. Instead of tire tracks or human footprints, this rippled dune records the passing of unknown creatures whose paths crossed in their nocturnal wanderings.

THE DESERT LILY is not only a beautiful spring flower but also has one of the most fragrant blossoms. It was a food source for Native Americans who called the plant the garlic lily because of the distinctive taste of the plant's bulb.

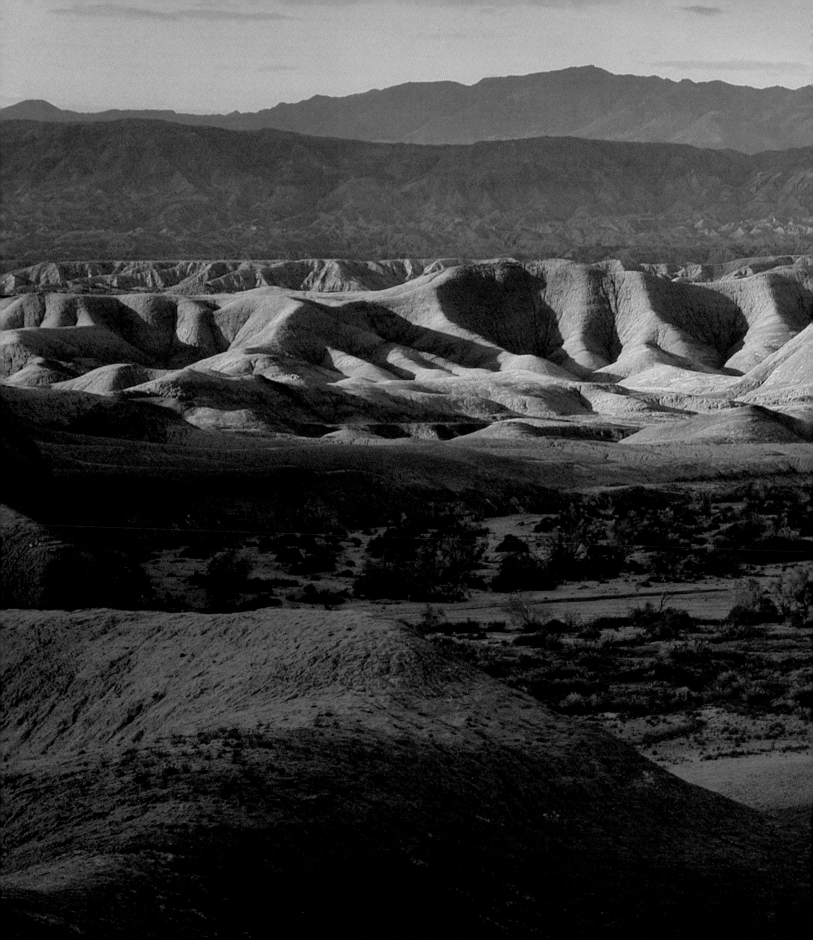

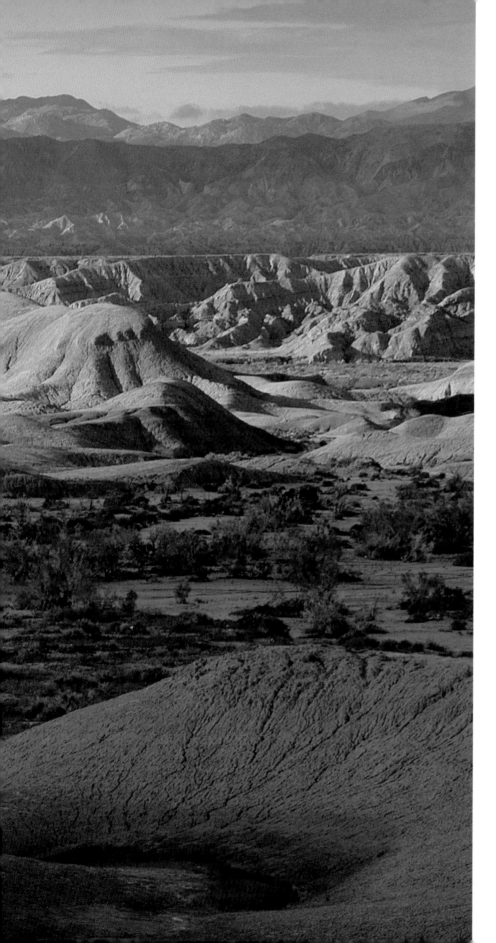

DAWN'S LIGHT, shining through a gap in a distant mountain, accents the deeply eroded terrain in the mud hills of the Carrizo Badlands. Once beneath a great inland sea and then transformed into a grassy savannah, the mud hills now hold buried treasure in the form of petrified trees and the fossil remains of long-extinct animals.

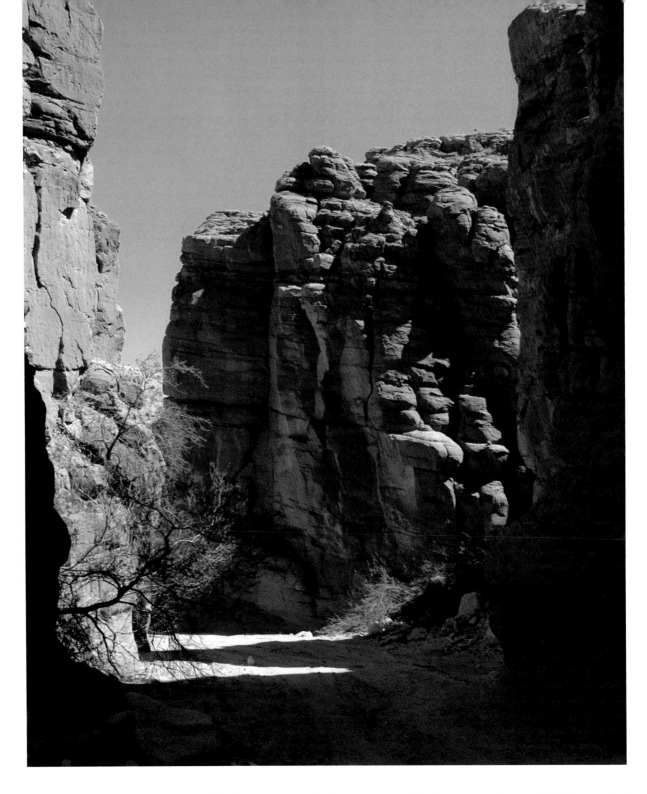

DEEP INTO FISH CREEK, a small side canyon extends for nearly two miles into the sandstone cliffs. The vertical walls tower over a canyon that narrows in places to barely more than the width of a vehicle. The towering buttresses are geological wonders where a visitor can be swallowed by silence, surrounded by whimsical forms created by the erosive forces of wind and water.

THERE ARE STORIES everywhere in the desert if the visitor is willing to take time to read them. Here, a sandstone concretion is being formed by the scouring effects of coarse sand—borne on the prevailing wind, it slowly and methodically etches away softer layers, eventually leaving behind an odd-shaped artifact.

IN SOME OF THE MOST ARID and harsh environments of Anza-Borrego can be found some of the most rare and beautiful gems of the desert. The Borrego aster is a delicate blossom of purple petals surrounding a brilliant yellow eye. Found only in areas around Salton Sea, the Carrizo Badlands, and Fish Creek, this is another rare species that thrives because it grows in the protected environment of the state park. The showy flower may not be seen for years at a time, but it can be found hidden in places like Sandstone Canyon when spring rains have adequately dampened the arid sands.

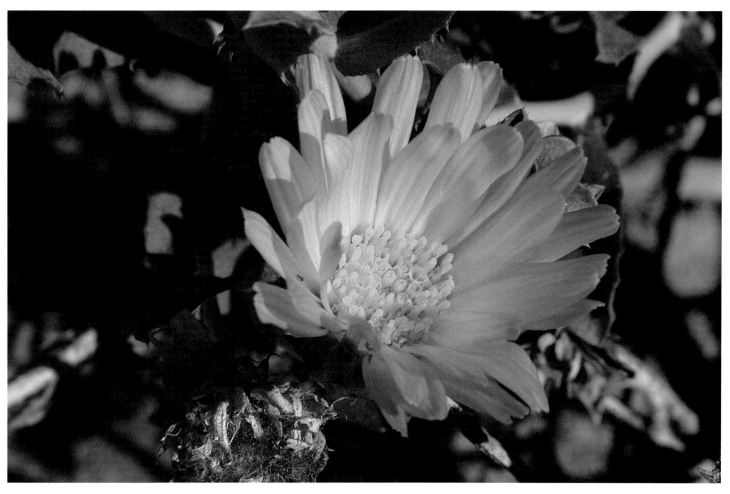

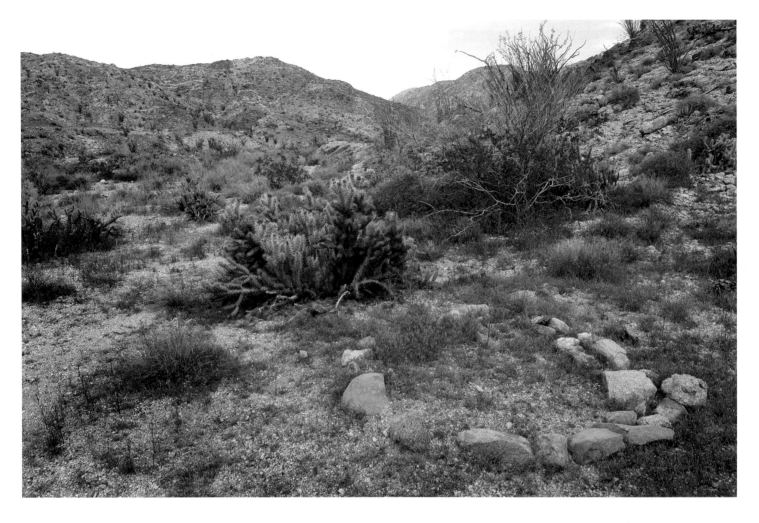

IN REMOTE PLACES you might encounter rocks that once formed the foundation of a crude shelter made of native vegetation, long since destroyed by wind and weather. The rock circles remain behind as evidence of the presence of the nomadic people who foraged in the desert in winter months.

THE LARGE, DELICATE trumpet of the Jimson weed is one of the showy flowers of the desert that also provides an important source of food for a honeybee. It was a sacred plant used in Native American ceremonies.

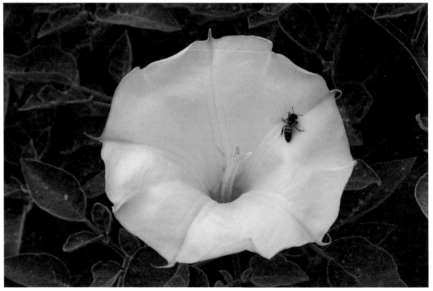

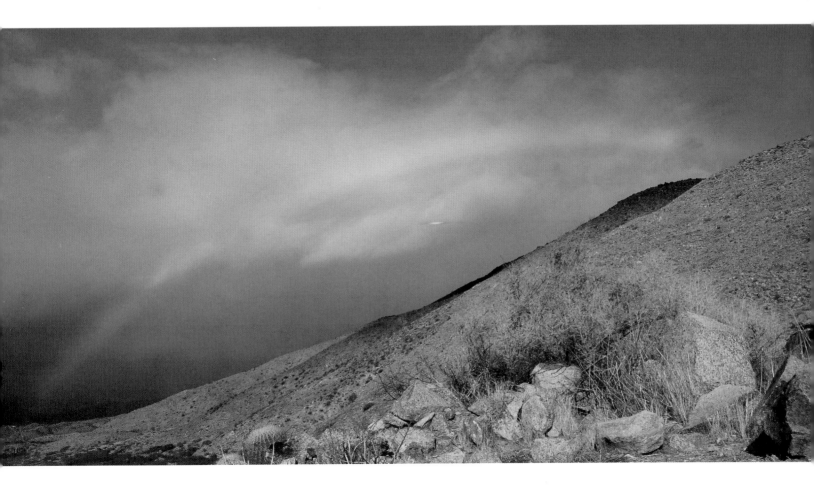

INSPIRATION AND BEAUTY come in many forms in the desert. Across a barren landscape, the advance of a mountain storm might bring raindrops that sometimes catch the rays of sunshine at just the right angle, creating brilliant but fleeting desert rainbows.

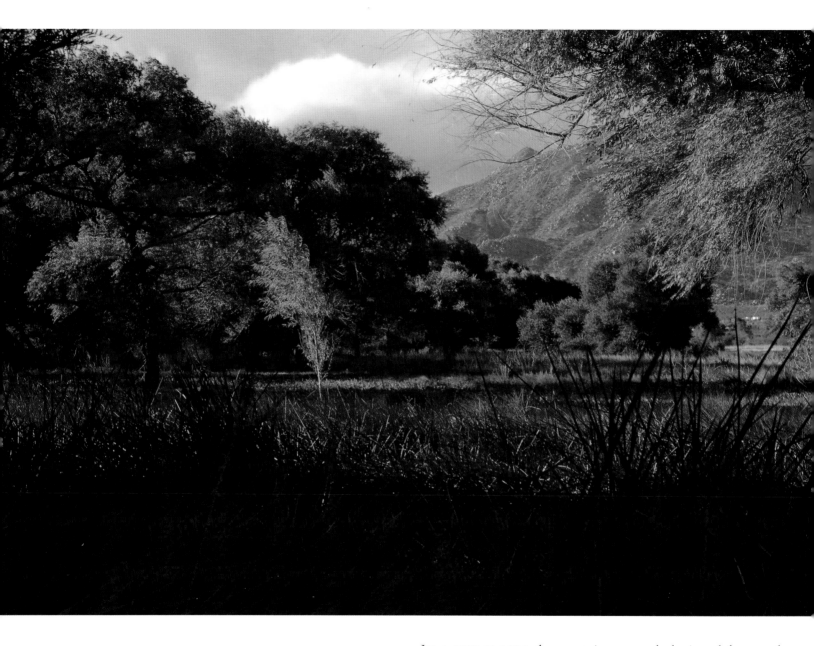

IN A FEW PLACES, the mountains surround a basin and the natural drainage creates a collection place for water. It's a different world, not filled with cactus and sand, but covered with cottonwood trees, cattails, and thick patches of grass. These are rich places where birds and animals find nesting sites, food, and dependable water.

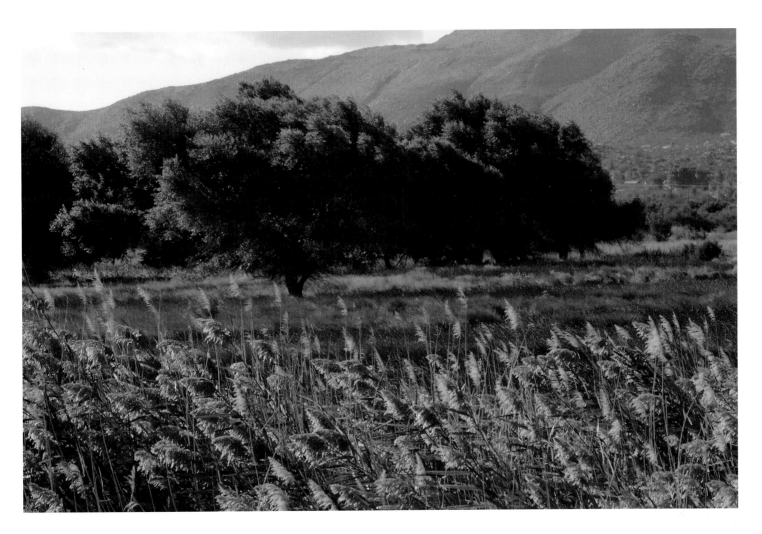

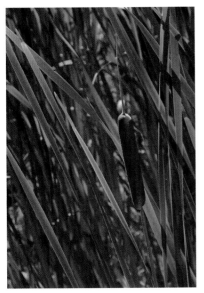

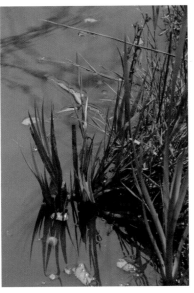

CHOREOGRAPHED BY THE WIND, the tall grasses of Sentenac Cienega dance in concert, their feathered tufts swaying. The abundant water allows tall trees to grow, creating an oasis of shade for both animal and human travelers in the heat of summer.

THE CATTAIL is a rare plant in the desert, found only where there is ample water. Native Americans most likely used the plant as a source of food—the root and lower stalk can be dried and ground into meal.

EVEN IN THE MOST ARID YEARS, the conditions that created the marsh at Sentenac Canyon mean there will be standing water, the lifeblood that sustains the plants and animals here.

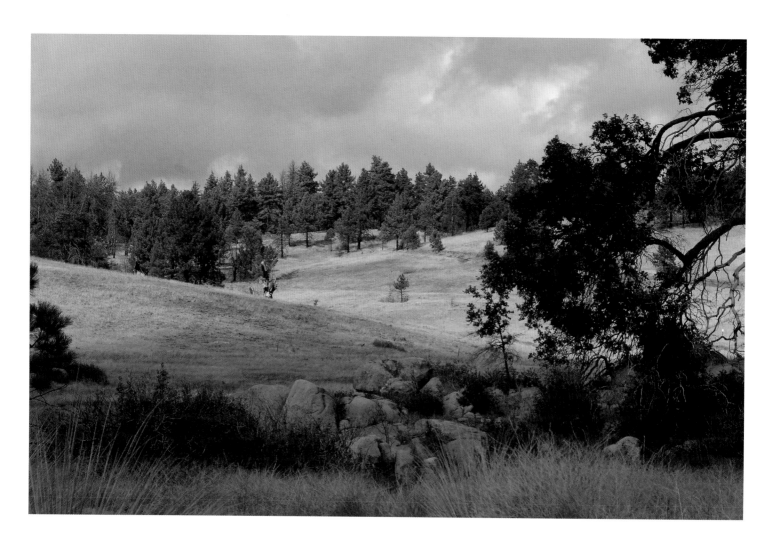

TODAY THE VISITOR to Anza-Borrego can explore an unbroken expanse of park that stretches from the desert floor to the peaks of the Cuyamaca Mountains. Linked by history and geography, the region was once home to nomadic tribes seeking food and shelter in the mountains during summer, and the milder weather of the desert in winter.

THE LIVE OAK TREES of the Cuyamaca Mountains hang heavy with a fall crop of acorns. Now they provide food for deer, wild turkey, and small animals, but once the native people who summered in the mountains would harvest and store them as a food source for their winter trips into the lower elevations of the desert.

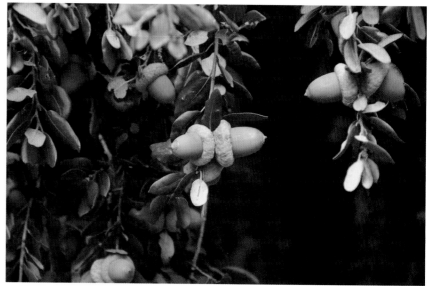

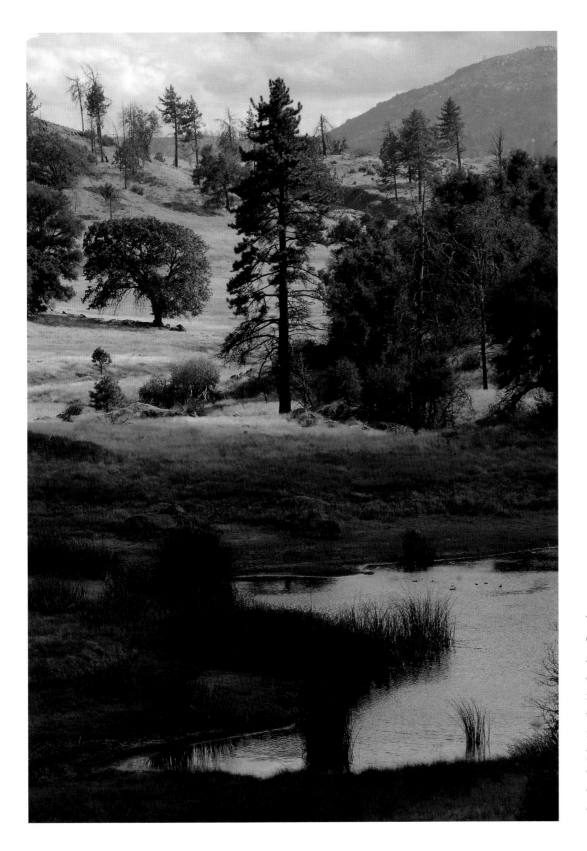

THE PINE-COVERED
CUYAMACA MOUNTAINS
are a natural barrier that
captures most of the rainfall
from coastal storms, creating
the arid environment just a
few miles to the east. The tall
pines, fields of grass, herds
of deer, and plentiful wildlife
offer a stark contrast to the
desert sands of Anza-Borrego.

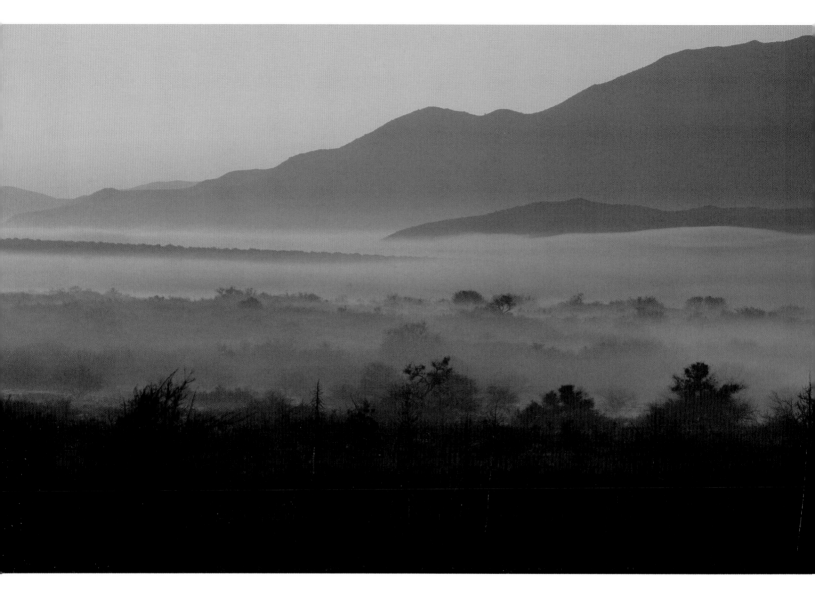

FOG IS NOT A FREQUENT EVENT in the desert, but when the winds are calm and a moist air flow drains from the mountains, the cooler air on the floor of Shelter Valley (also known as Earthquake Valley) creates a thin blanket of gossamer fog that changes the landscape from sharp and clear to still and mystical.

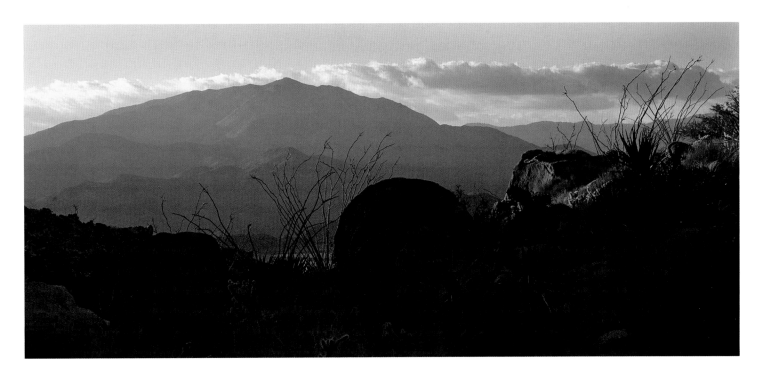

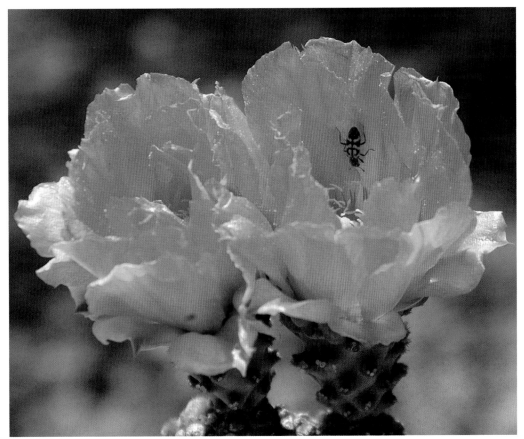

THE SOFT LIGHT of sunset, a cloud cap on distant Granite Mountain, and a view that has not changed since this trail was used by native travelers a thousand years ago—for a moment there is a connection in time as today's eyes share the view with the eyes of the distant past.

A TINY BEETLE, the ornate checkered beetle, adds to the brilliant color of a blooming beavertail cactus, but for the insect, it is only the feast of spring. To the visitor it is another of the marvels of beauty and wonder that can be found in Anza-Borrego.

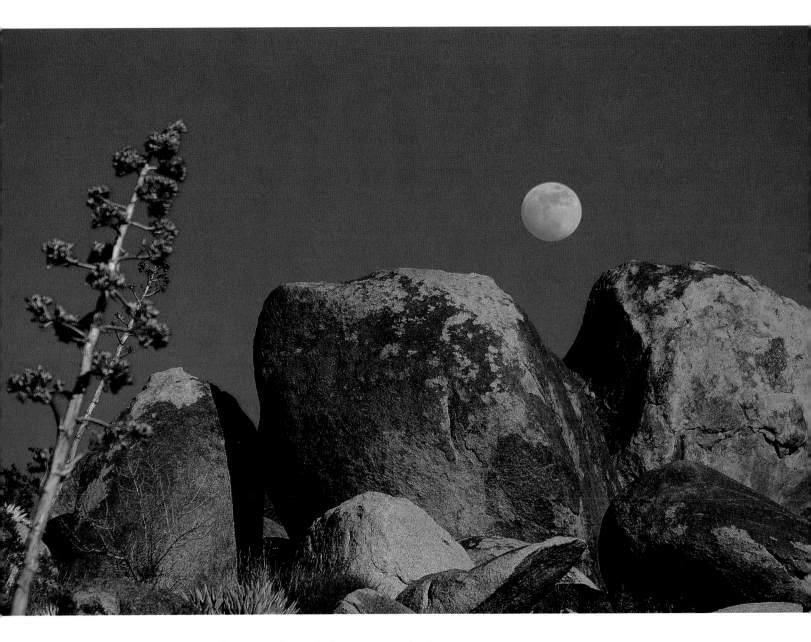

AS THE HOUSE LIGHTS of sunset are lowered, the center stage is taken
by the nearly full moon rising over an eternal audience of desert plants and
boulders. The traveler who is lucky enough to see this special show will be
witness to a grandly poetic, unforgettable performance.

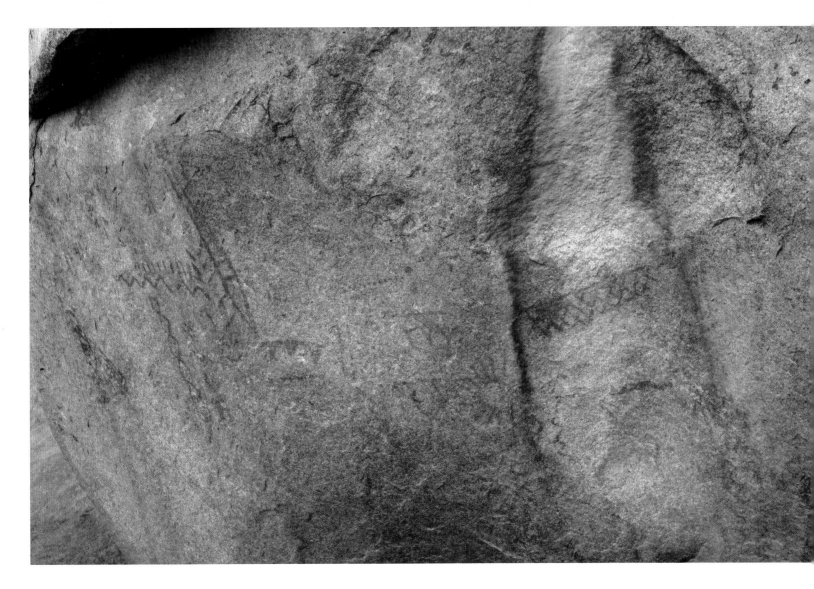

SOMETIMES FADED BY TIME and the harsh environment, the ancient artists' cryptic messages are left for future generation to ponder. Were they symbols of religious significance, special events, or simply the doodling of a native artistic hand?

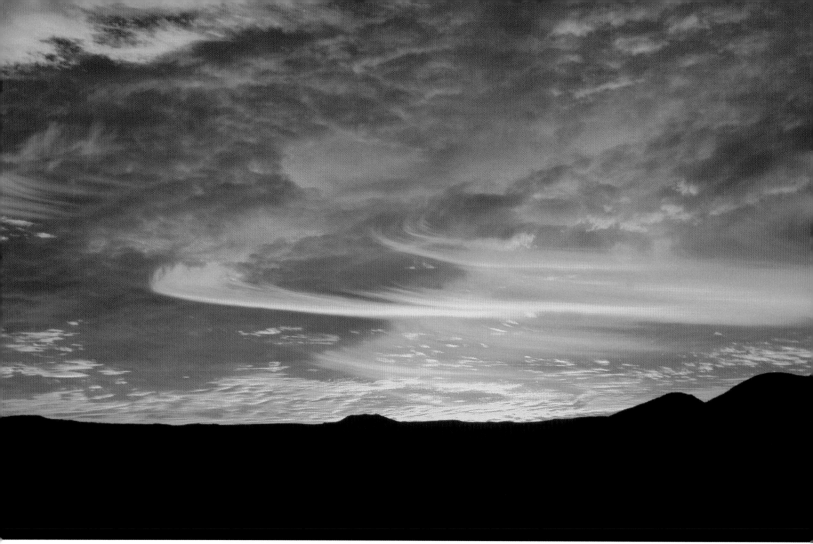

THE DESERT TRAVELER lucky enough
to be out at dawn may be treated to a grand
announcement of the coming day with crimson
clouds blowing through a deep blue sky. The
wind-swept clouds catch the first rays of sunlight
and blaze for only minutes until the brightness
of daylight washes out their color.

MUTED HUES from the refraction of air-borne
dust and the warm glow of a full moon create
a scene that seems unreal when captured in a
photograph. Alone in the desert, surrounded
by the profound silence, indescribable beauty
touches our souls and nourishes our spirits.

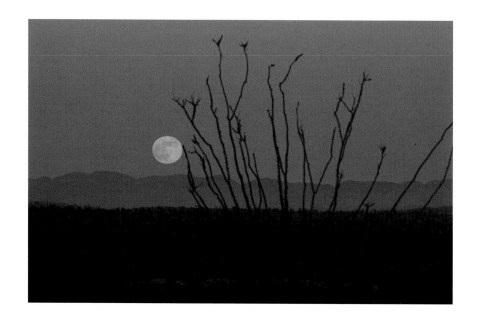

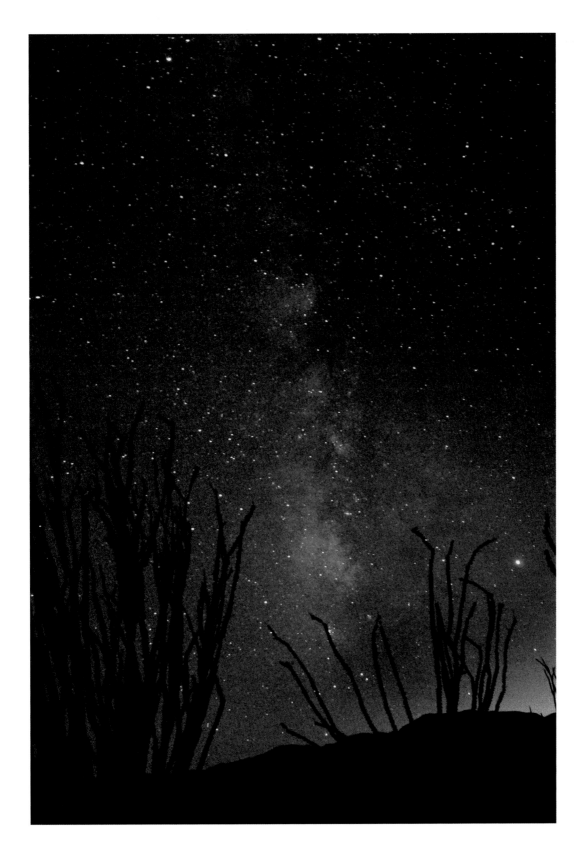

THE STAR CLOUDS of the Milky Way are bright and visible in the sparkling clear sky over Anza-Borrego. Seldom seen by city dwellers, the spectacular show of a truly dark night can be as awe inspiring as the desert's most scenic daytime view.

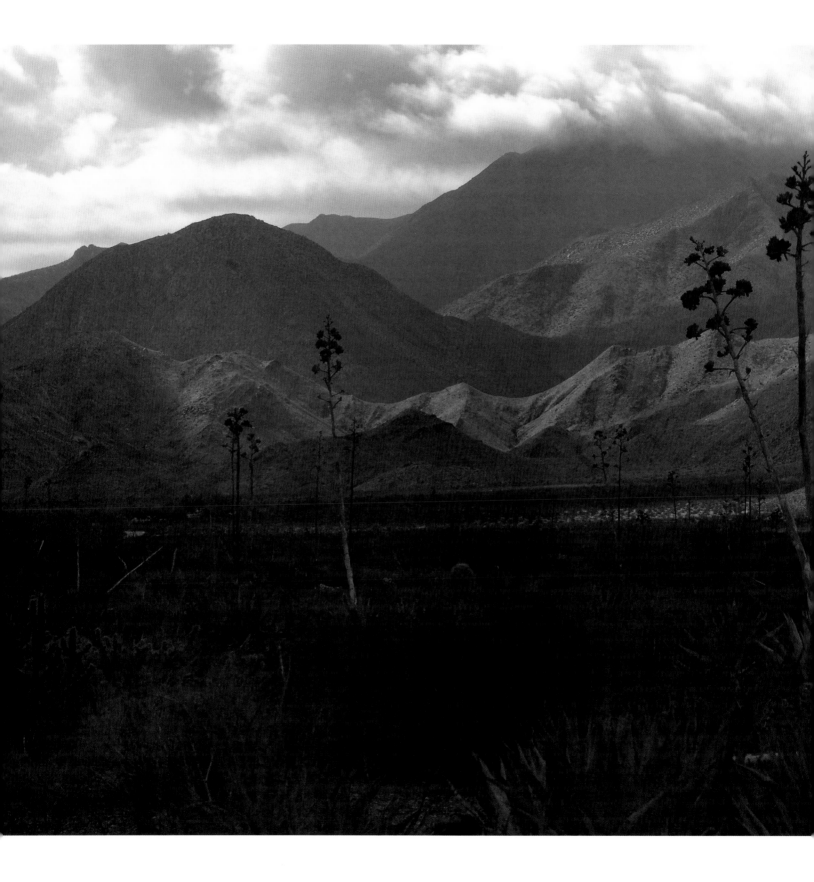

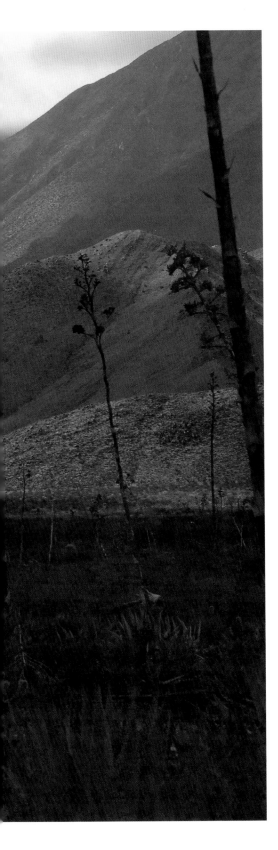

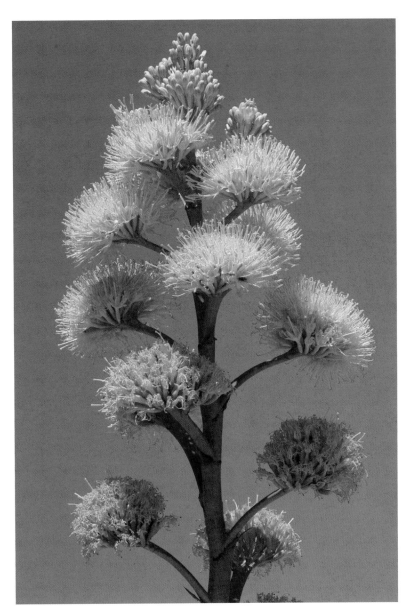

AN ARMY OF AGAVE SOLDIERS stand in formation in Mason Valley as cloud patterns dance across the face of distant mountains. This terrain, open to long views and swept only by the touch of nature, is one of the desert's most alluring features.

THE BLOOMING AGAVE STALK can grow up to 13 feet tall in a mature plant and offer food for both animal and man. Birds, bats, and insects thrive on the sweet nectar of the large yellow flowers, and the pulpy base and stalk of the plant can be roasted—when cooked, it tastes much like molasses-sweetened squash. Unwary desert hikers may encounter the painful stab of the agave leaf, tipped with a sharp needle-like spike.

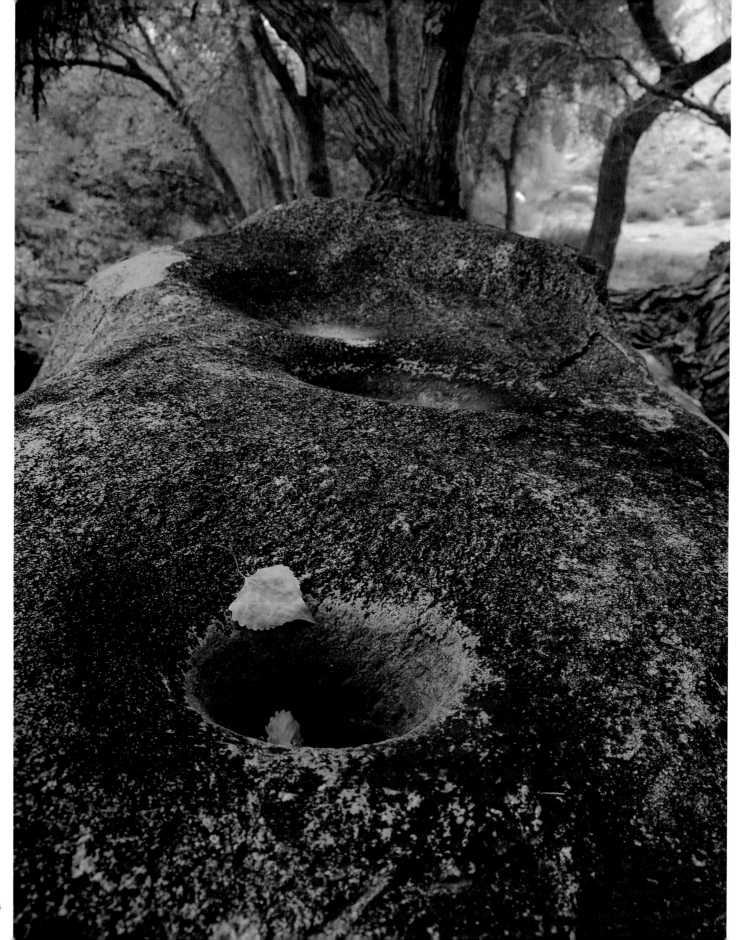

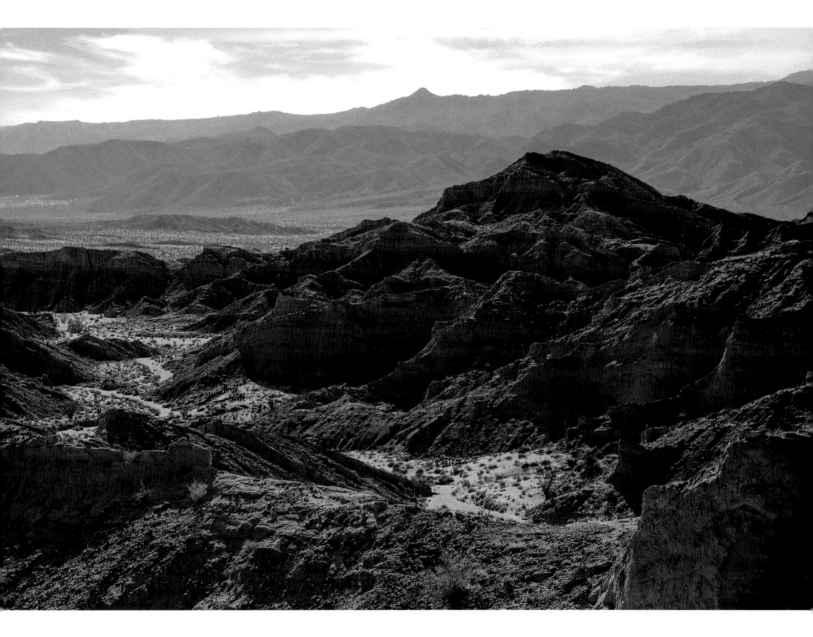

MANY DEEP CANYONS ascend from the desert floor into the heights of the Laguna and Cuyamaca Mountains. There is water in these canyons and the shade of huge cottonwood trees that for centuries provided cool shelter for the native people who gathered here. Deep holes were carved into the rocks as seeds were ground by hand into a fine meal used as a food staple by these early people.

THERE ARE COUNTLESS meandering washes in Anza-Borrego, but each one offers something different — a unique rock formation, a new water hole or palm grove or simply towering sandstone pyramids that invite exploration. A lifetime is not sufficient to wander enough in the open wilds of the desert, absorbing the spectacular, the ordinary, and the minute beauty to be found.

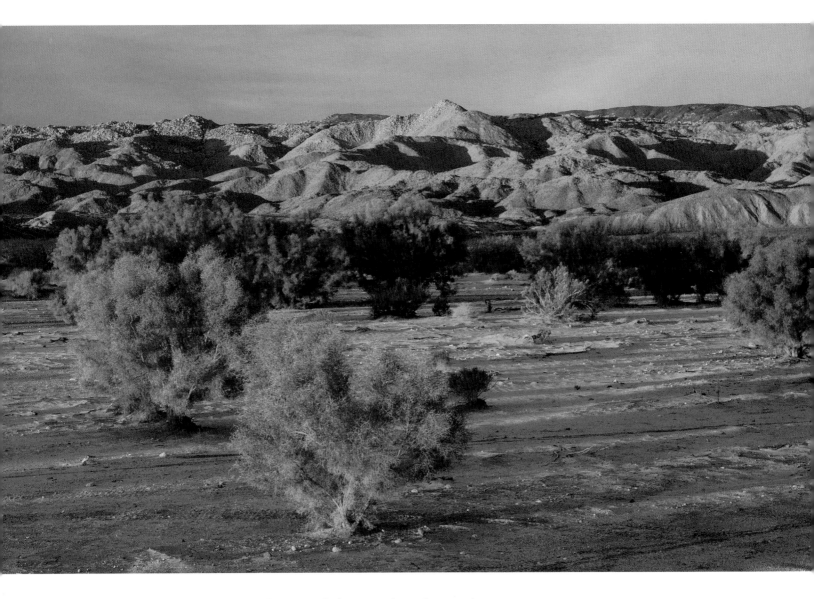

DISTANT SOMBRERO PEAK was first to catch the warm glow of sunrise that now begins to lighten the forest of smoke trees in Vallecito Wash. Mornings are often still as the slumbering land seems to gently awaken to the fullness of a new day.

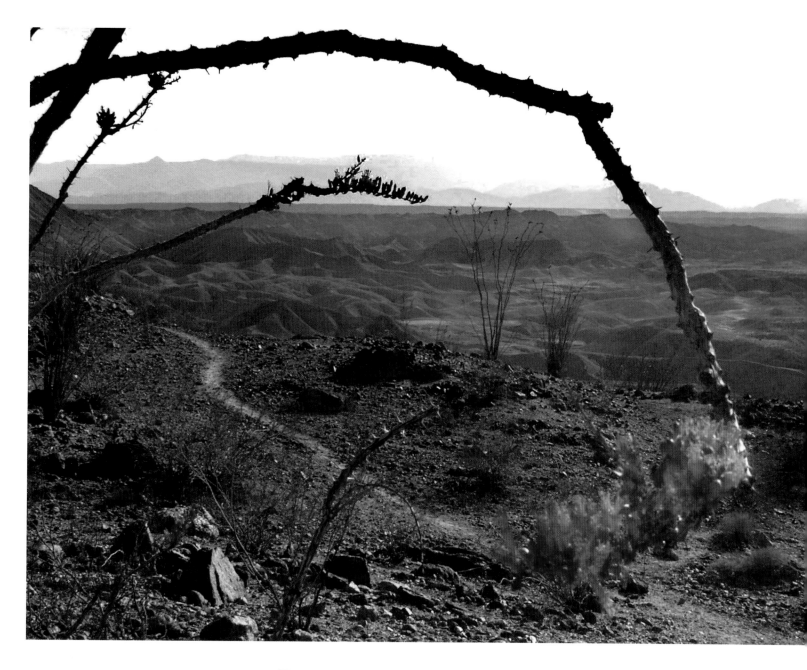

THE FIRST TRAVELERS through the stark and barren Carrizo Badlands traveled on foot, leaving behind well-worn pathways still visible today. With little water here and sparse wildlife, this was a transition area where native people lived while gradually moving from the shores of a great inland sea to more abundant areas in the western desert.

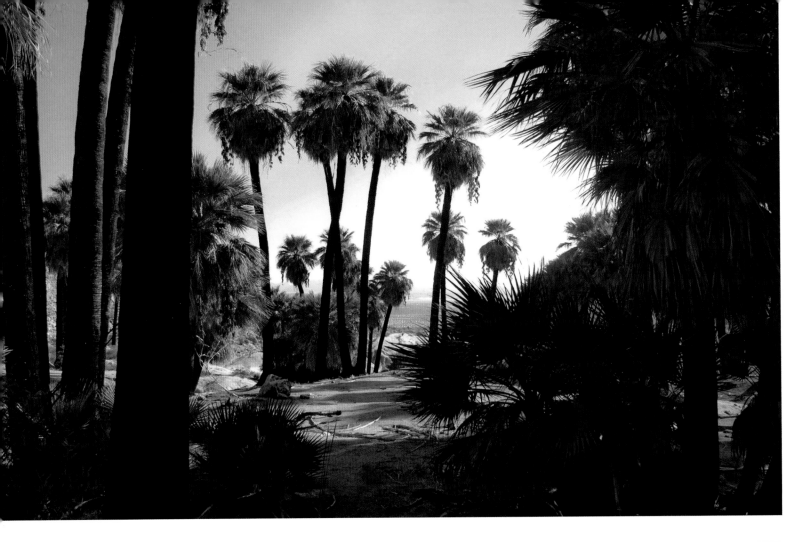

FEW OF THE PALM GROVES of Anza-Borrego
are available by vehicle. But hikers who trek to the
isolated groves are rewarded in many ways — often
sharing the shady quiet with birds, insects, and animals
that also know this as a wayfarer's comfort station.
Southwest Grove is the largest palm grove in the
Mountain Palm Springs area.

THE SYMMETRICAL LEAVES of the palm frond
branch into feathery strands that are used by birds as
nesting material. For centuries Native Americans also
used palms as a source of fiber to weave baskets. In an
arid, often barren land, the few plants that do thrive are
useful for both man and animal.

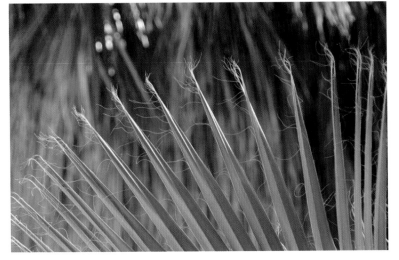

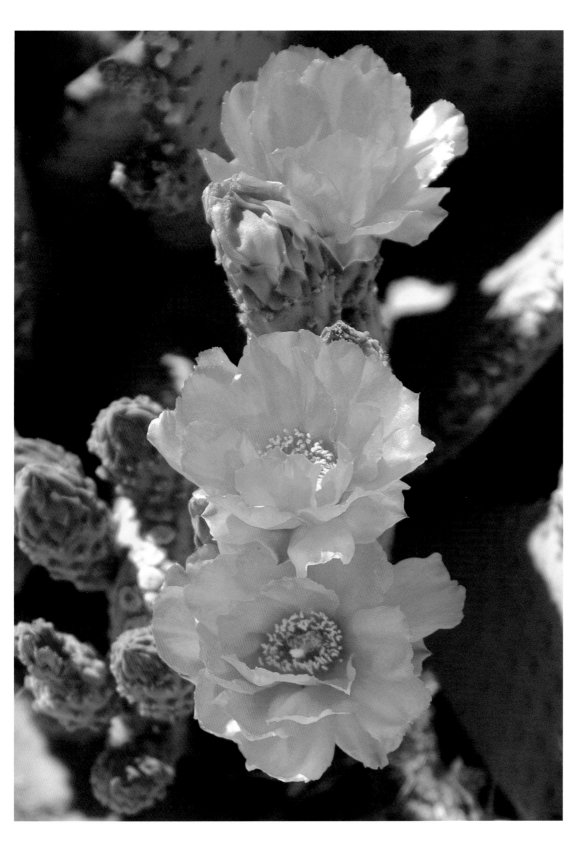

THE BEAVERTAIL CACTUS offers some of the most colorful flower displays in late spring. Some might call them magenta and others pink, but the delicate, crepe-like blossoms are certainly stunning and vibrant.

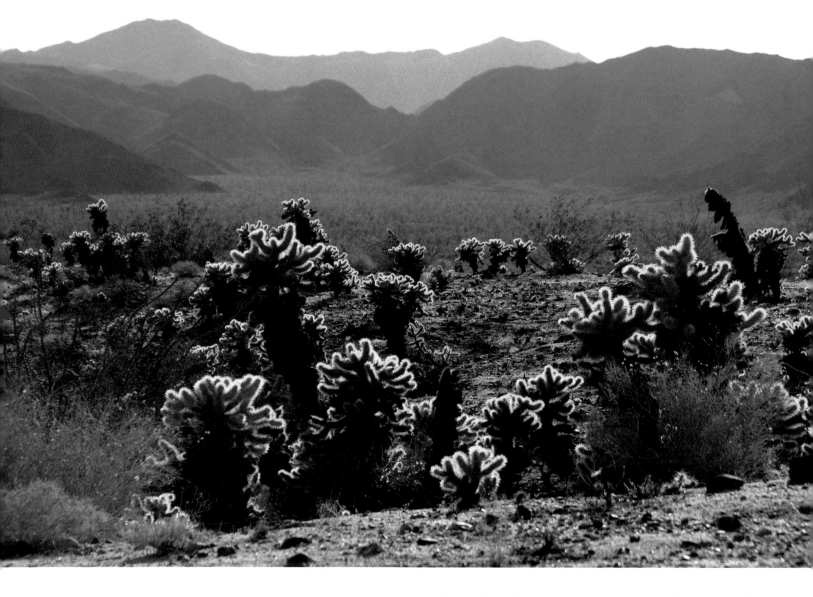

LIKE SOLDIERS OF AN ADVANCING ARMY, a forest of cholla cactus spreads out over the flats into the distant Jacumba Mountains. Despite its threatening needles, the cactus offers food and shelter for many desert dwellers.

THE BARBED SPINES of a buckhorn cholla cactus offer a comfortable home site for the cactus wren who builds its nest in the thorny arms of the plant. The casual observer might not even notice the nest, but learning to see and understand the ways of desert plants and animals helps make each trip more intriguing.

THE CANE CHOLLA is one of the more spectacular cactus plants with blood-red flowers that bloom in late spring.

WHEN SEASONAL BLOOMS paint the tips of the buckhorn cholla with bright green flowers, its spines seem a bit less threatening. An ornate checkered beetle answers the invitation of spring, thriving on the plenty and contributing to the survival of the cactus by carrying pollen to other plants.

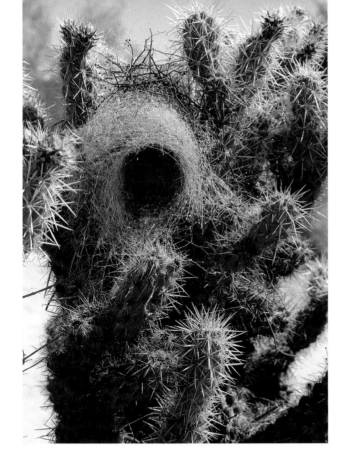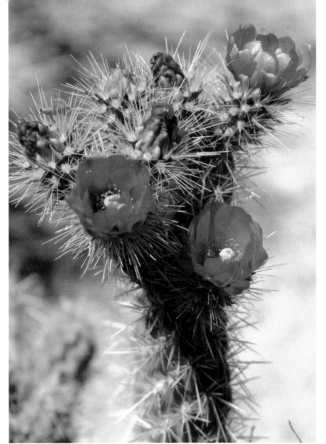

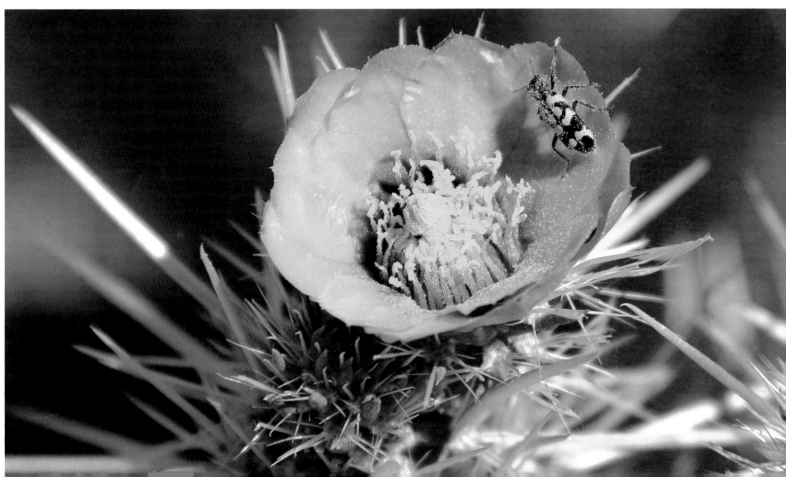

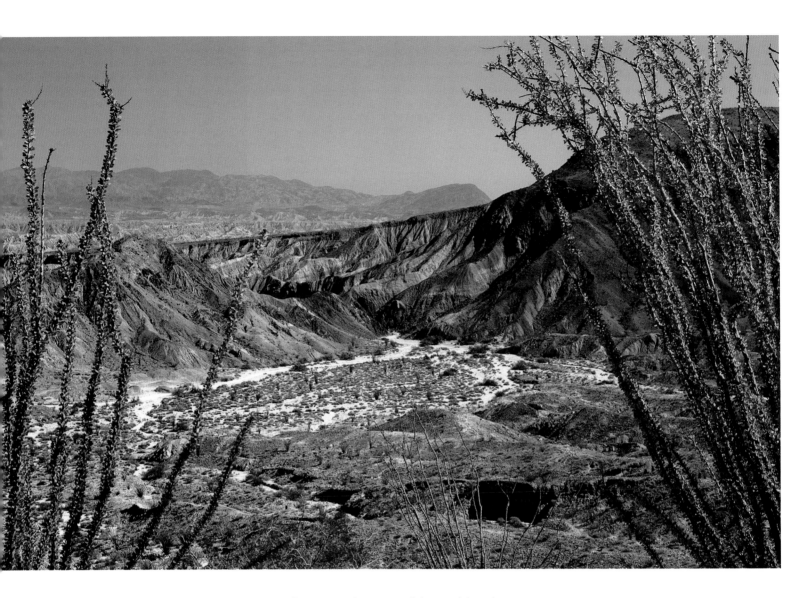

IT'S CALLED CANYON SIN NOMBRE, "canyon with no name," but could easily be called "The Rabbit Hole" because visitors who tumble into it find themselves in a wonderland of geological beauty. Colored layers of sandstone and rock, and narrow passageways cut deeply into towering cliffs, make up a broken landscape that eventually opens into the Carrizo Badlands with miles of mud hill mazes to be explored.

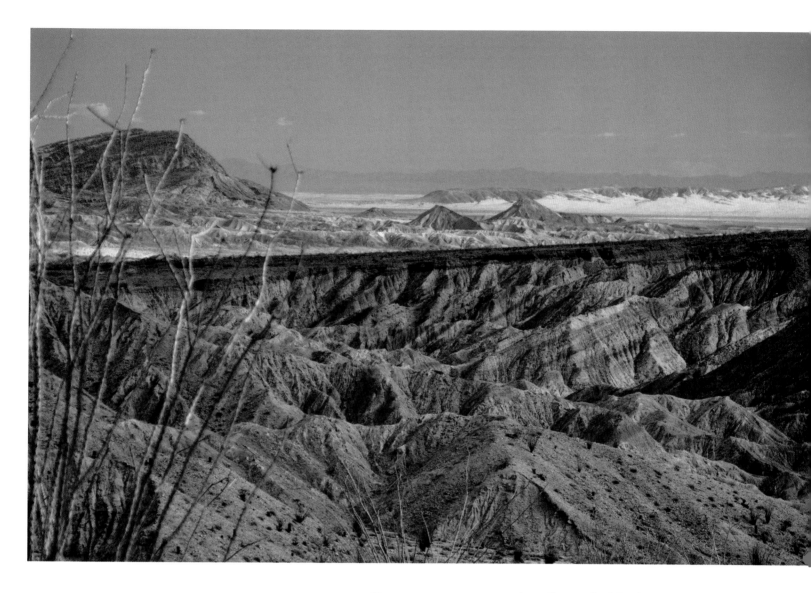

FROM THE OVERLOOK above Canyon Sin Nombre, one gets a grand
view of creation. The stacked layers of sandstone and mudstone create
a foreground pattern of tilted layers while, in the distance, mountains
formed by heat and fire rise like sentinels in a sea of shifting sands and
ancient seabed sediments.

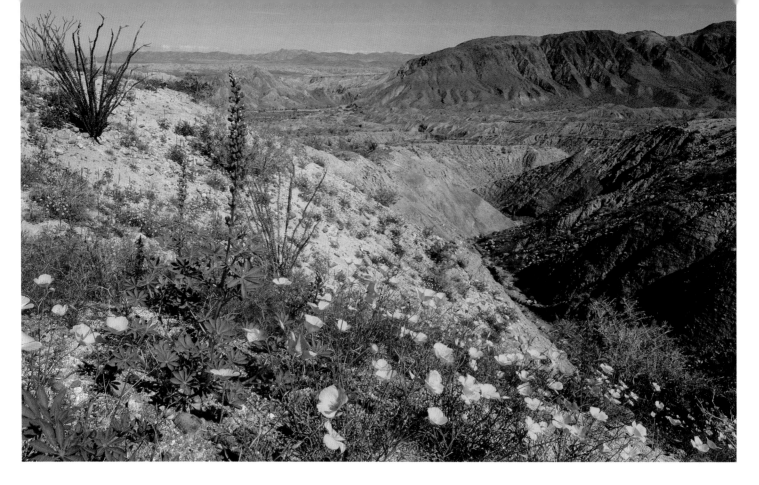

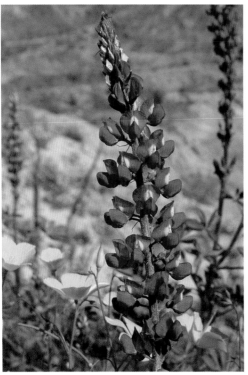

A COLORFUL BLEND of bright purple and vibrant yellow coat this sandy hillside approaching Carrizo Badlands Overlook for the few precious weeks of a spectacular spring display. Soon the warm winds of summer will wilt the flowers and their seeds will disperse into the sand to await the next season's late winter rains.

THE DEEP PERIWINKLE-BLUE of lupines contrast beautifully with the brilliant yellow dune poppies — when Nature creates an abundant wildflower bloom, the offerings have a broad enough color palette to please any taste.

STANDING LIKE CASTLES of sandstone, the towering cliffs of Canyon Sin Nombre are cut by deep fissures that snake deeply into the canyon walls, narrowing down to slots no wider that two or three feet. Often the narrow canyons act as secret passages climbing to the plateau above and opening to another world to be explored.

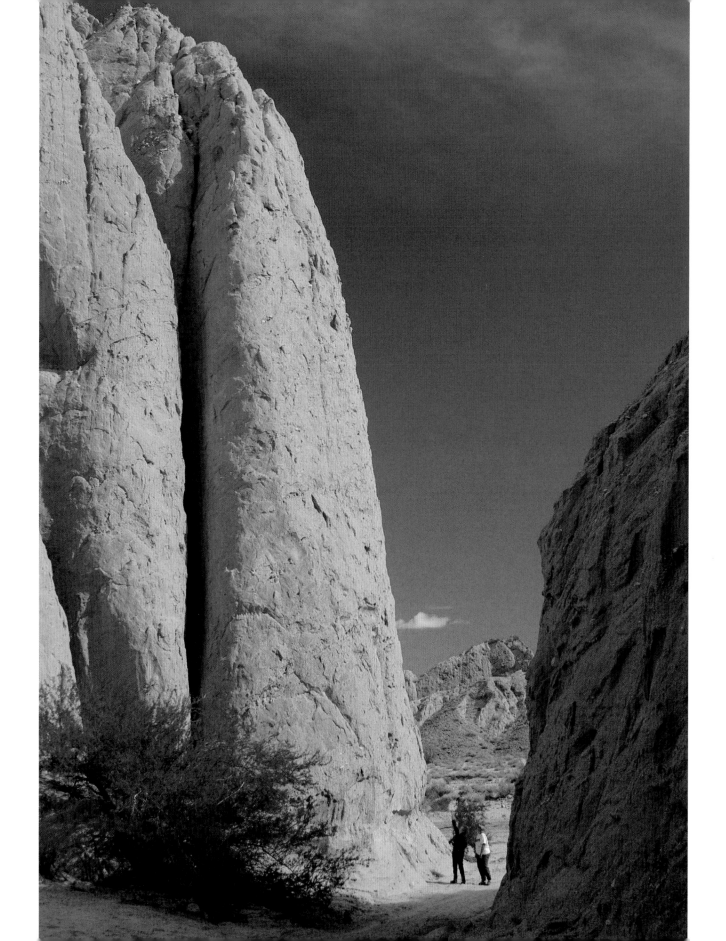

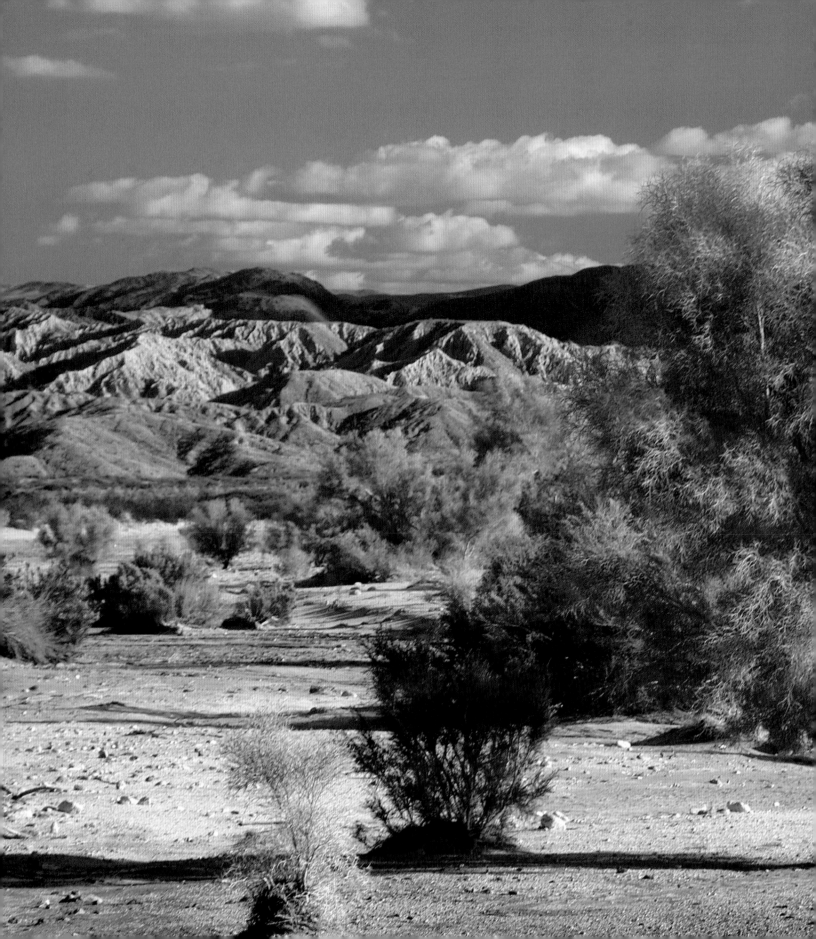

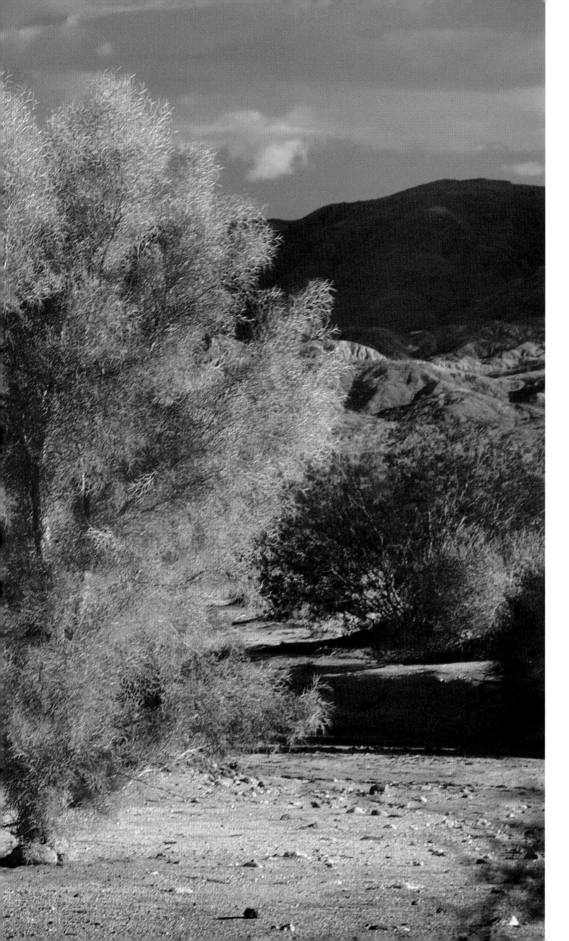

LOOKING LIKE WISPS of
rising smoke from a distant
campfire, the smoke trees that
fill desert washes are aptly
named. These hills in Vallecito
Creek once defined a route
used by early explorers, fortune
seekers, and settlers heading west
in horse-drawn Concord coaches.
Some long-ago outposts and
way stations are preserved along
this route, and modern campers
may slip away from today's
world and sleep with the ghosts
of ancient travelers.

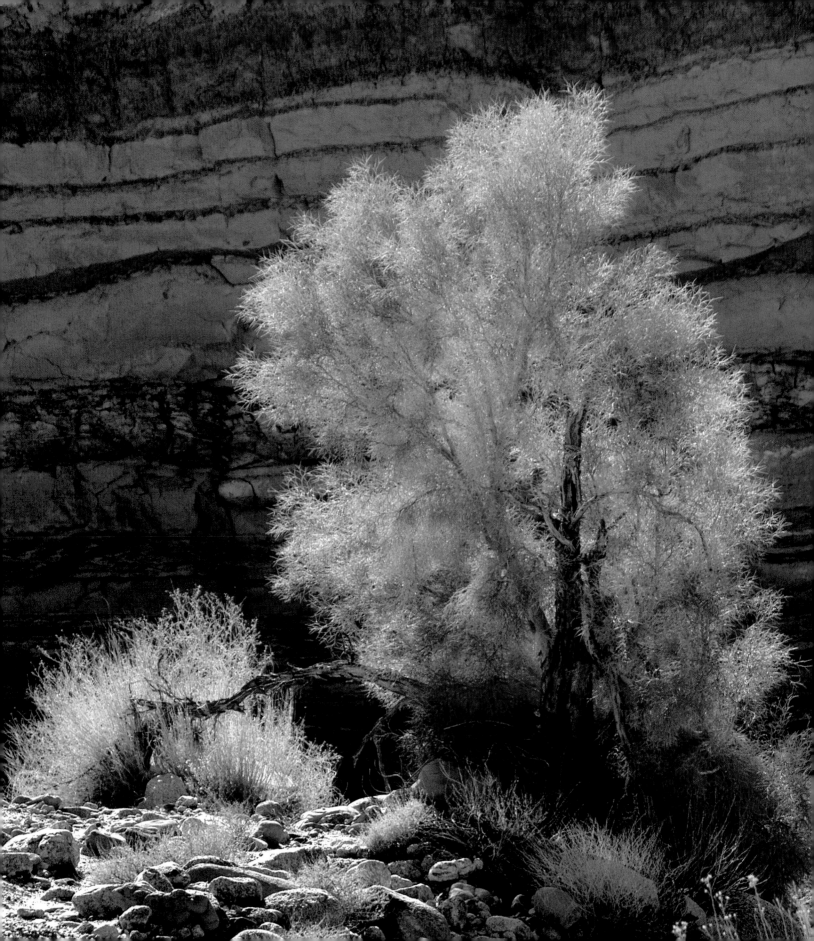

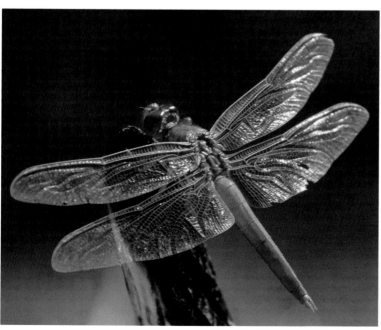

SOFT RAYS OF LIGHT shining through the feathery leaves of a desert smoke tree are framed by the mosaic layers of ancient rock that were once under a great inland sea.

RUNNING WATER is rare in the desert, but an isolated marsh has been created in a low place just east of where Vallecito Creek joins Carrizo Creek. Here the desert is covered with thick vegetation, and the perennial water source hosts species of animals and birds rarely found in the desert.

ONE OF THE MORE spectacular insects that frequent the palm groves and water holes of the desert is the red skimmer dragonfly. The intricate structure and gossamer wings of a dragonfly allow it to dart quickly from place to place or hover like a hummingbird. Those abilities—and its bright color—make it a distinctive resident of the desert.

ERODING CLIFFS in the Carrizo Badlands expose thin layers of ancient ocean sediments deposited by the rhythmic ebb and flow of the tides that flowed here millions of years ago. Enormous pressures from the earth's movements have tilted and folded the layers into wavy lines.

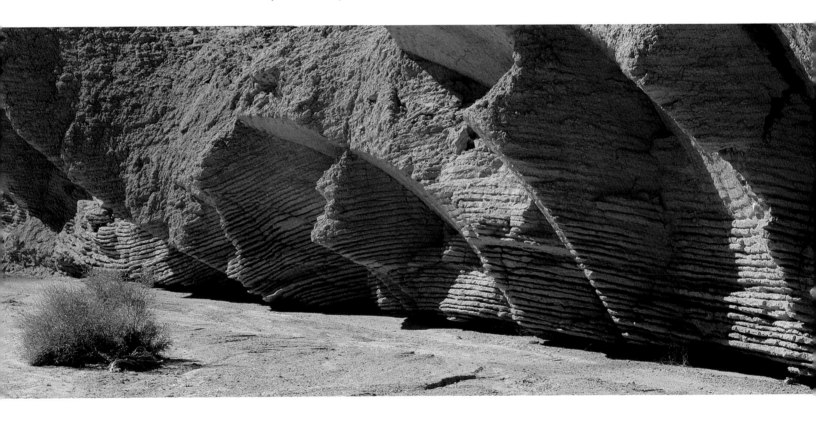

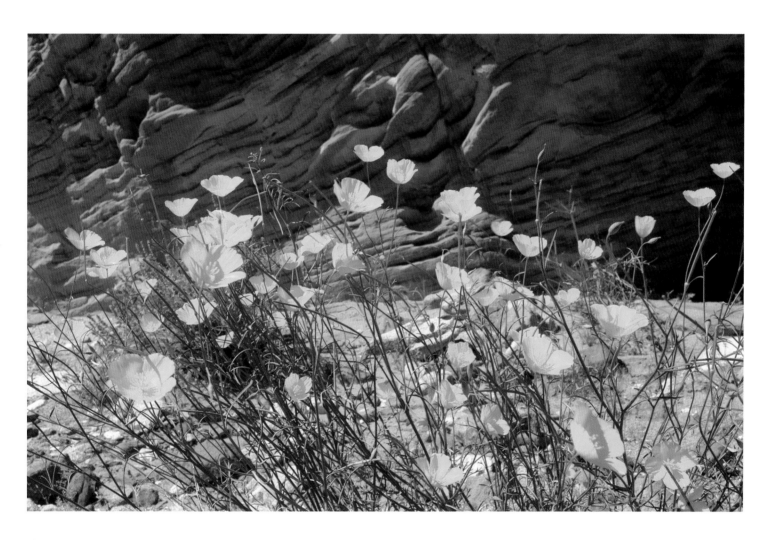

A CLUSTER OF DESERT POPPIES adds to the bright red sandstone formations in a remote canyon of Fish Creek.

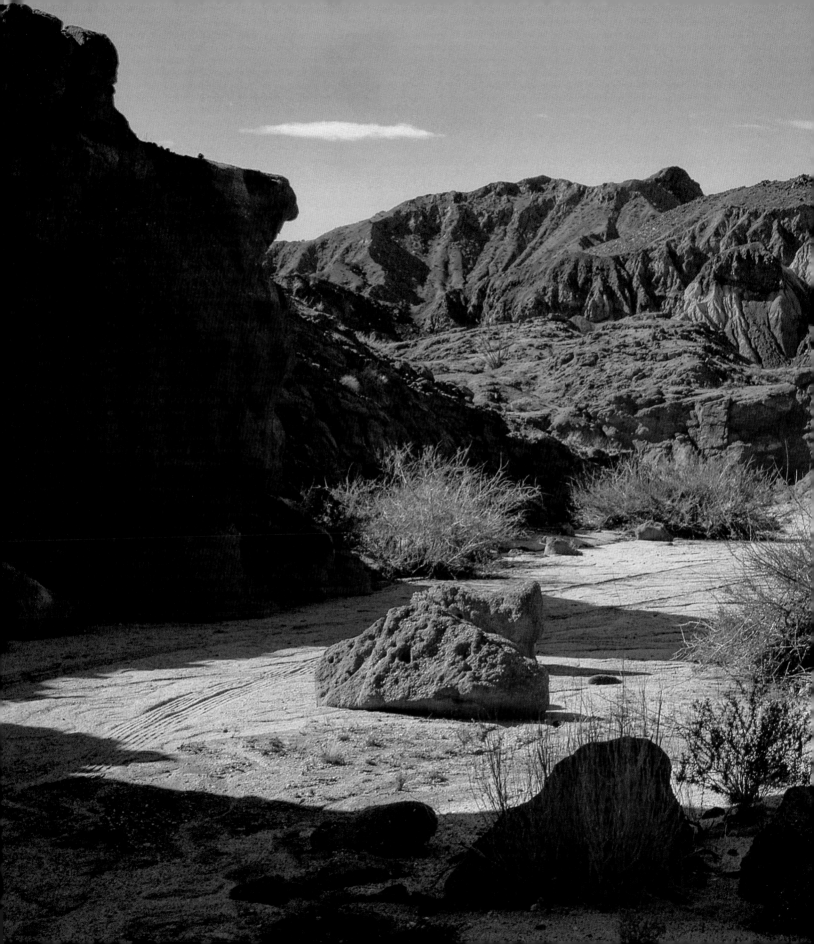

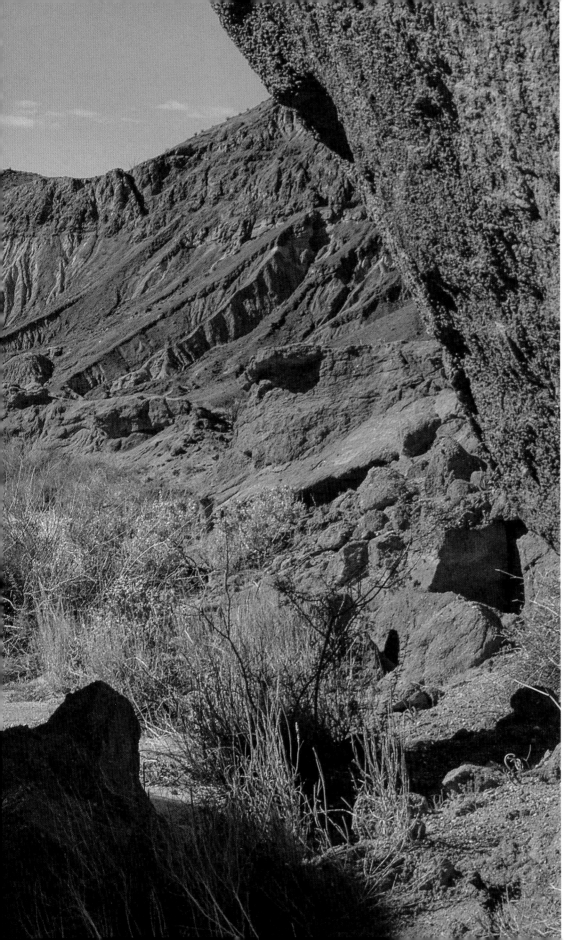

THERE ARE PLACES in
the Coyote Mountains where
tectonic forces have allowed
erosion to open wounds in
the earth to expose the many
red, gray, green, purple, and
black layers which had been
deposited by torrential floods
and ancient lakes and seas.
The exposed layers have been
sculpted and carved by wind
and water into a kaleidoscope
of natural color and form.

FOLLOWING PAGE:
THE FORMS OF TUMBLED
BOULDERS are mirrored in
the billowing clouds of a
winter sky as the solitude
of a trackless wash invites
exploration into the Carrizo
Badlands.

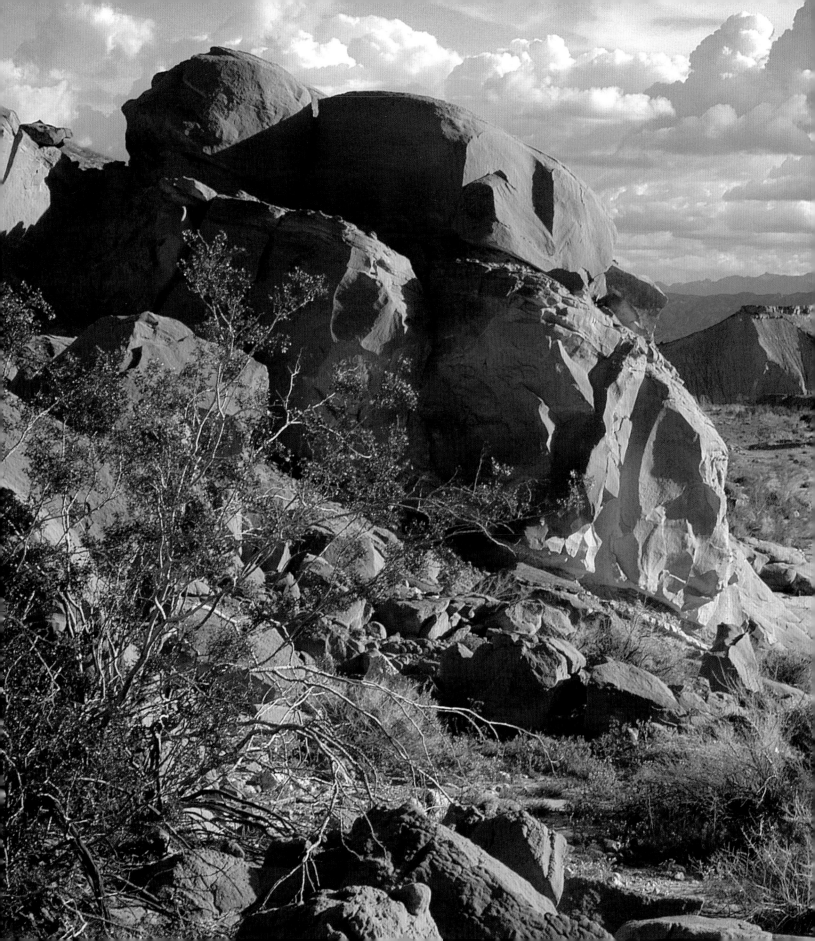

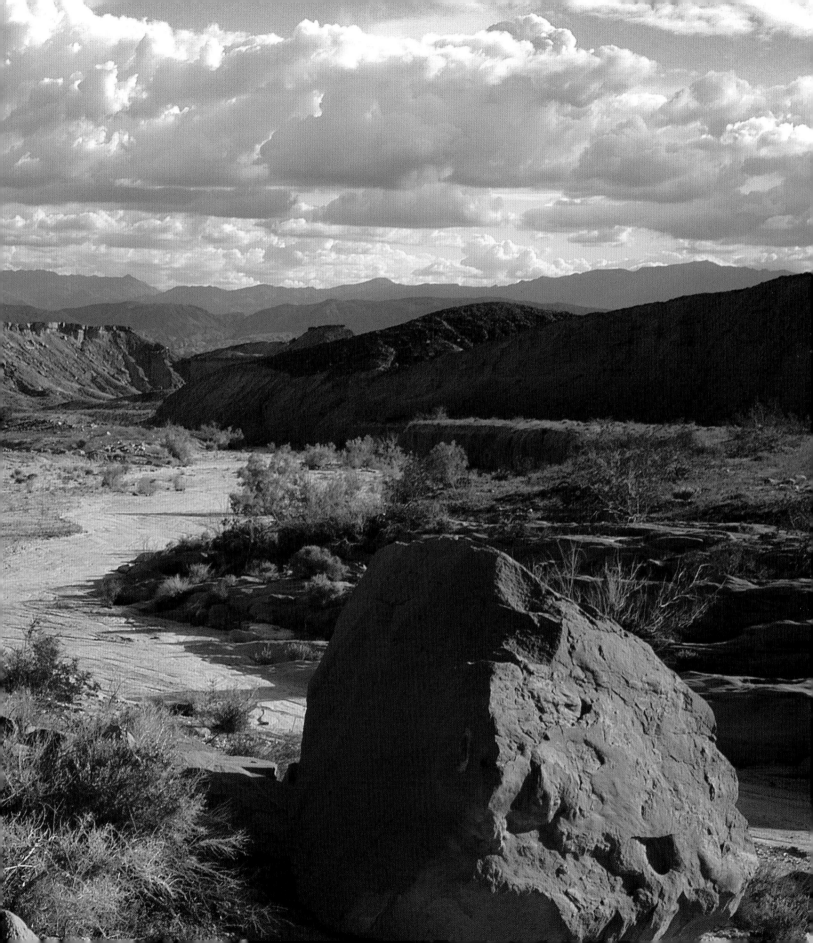

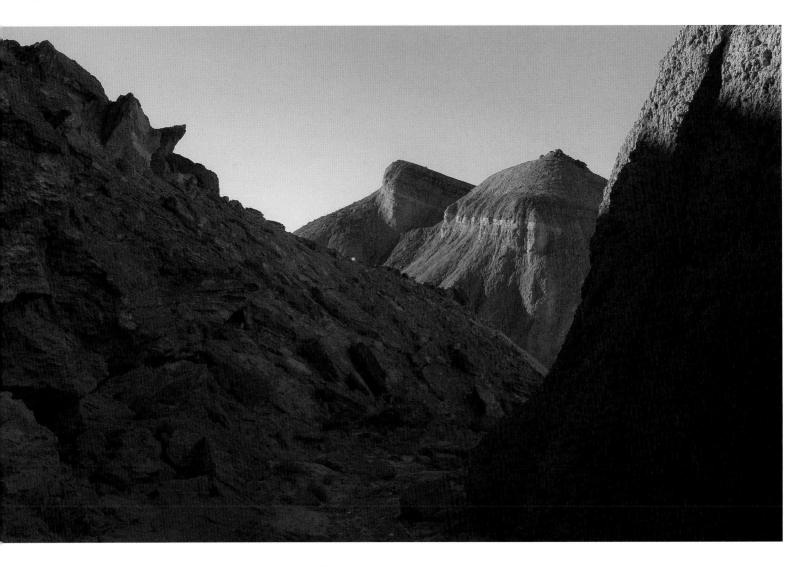

AN ENCOUNTER WITH big jackrabbits, the discovery of a long hidden fossil, or simply the gentle shadows of the deep canyons, await hikers who wander the mazes of the Carrizo Badlands. Here the canyons are illuminated with an alpenglow of reflected light.

HANGING LIKE CHRISTMAS ORNAMENTS from a creosote bush, the tiny seed capsules take on a fuzzy glow in late afternoon sunlight. Each of the seed pods holds five seeds that will soon drop to the ground. Those not eaten by birds or small animals may find the right conditions for another creosote bush to grow.

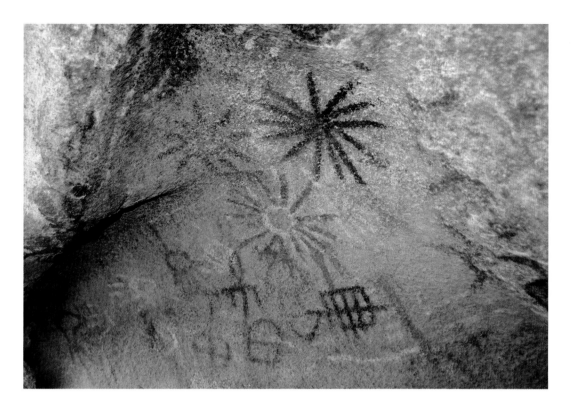

THE FOOTPRINTS OF THE ANCIENTS are gone from the shifting desert sands, but their spirit remains, along with the cryptic symbols they painted in sheltered caves. Sitting quietly in a rock shelter, looking out at a scene as viewed centuries ago, perhaps even feeling the maker's finger marks in a piece of broken pottery, gives today's visitor some connection with the past. A quiet moment of reflection in these remote places lets one see life as it was for the Indians who called the desert home.

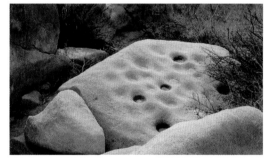

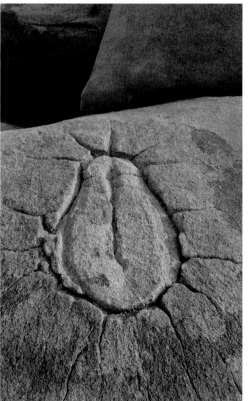

A LARGE BOULDER is dotted with small holes made hundreds of years ago by the native people who called the Anza-Borrego region home. It is unknown if the holes were utilitarian in nature, perhaps grinding holes for seeds, or if they are cupules carved during ceremonies for rain or fertility. Similar formations are found throughout southern California.

THERE ARE ROCK ART SITES in the desert where the early native people conducted ceremonies marking the passages of the seasons and of life. Rock carvings known as yonis, believed to symbolize fertility, birth, and the glory of womanhood have been etched into granite boulders at this special place near Dos Cabezas.

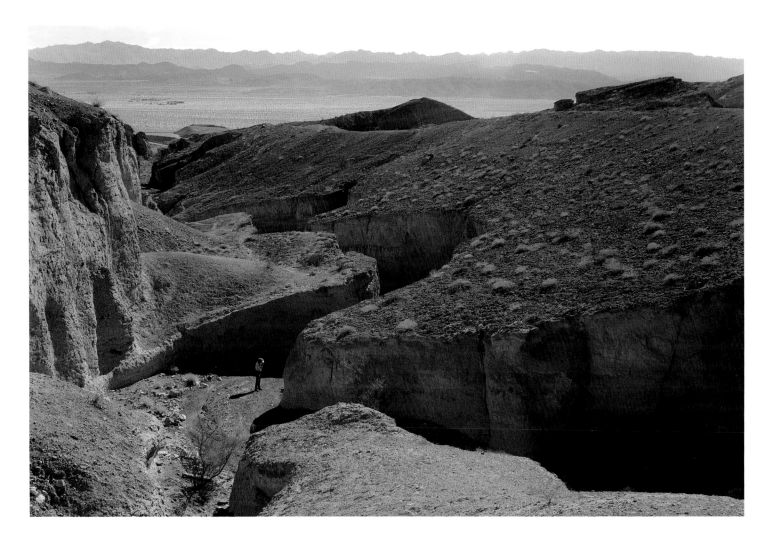

SHELL CANYON is a natural geological museum—the earth broke and tilted within a fault zone, then rushing water through the ages carved deep into the sandstone formations, exposing layers of petrified oyster shells and marine sediments dating back at least 4 million years.

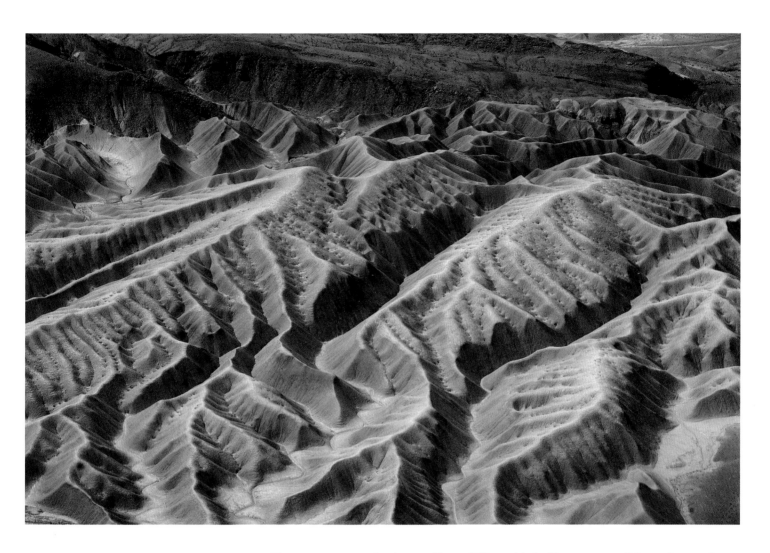

FROM THE AIR, the desert offers a different kind of beauty; one of shape, form, color, and texture that cannot be seen from ground level. Much of Anza-Borrego remains a trackless wilderness, free of roads, power lines, or buildings. Such vast beauty, rare in an increasingly urban world, is preserved here for present and future generations to enjoy.

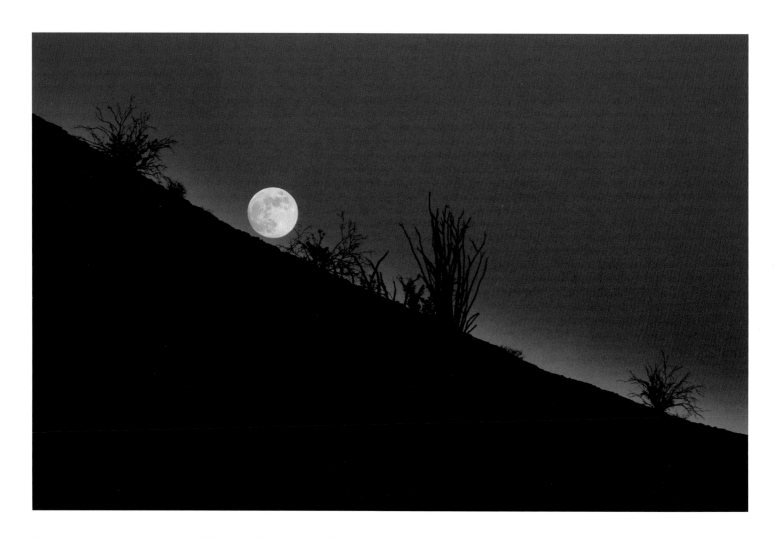

THE SOFT LIGHT of a desert full moon illuminates a different world. Creatures that are never seen during the day will come to life. Sharing a nighttime campsite with the curious desert kit fox, or discovering the nocturnal movements of feeding snakes, kangaroo rats, or a rare ring-tailed cat is a unique experience for the nighttime visitor.